LANDFALL 237

May 2019

Editor Emma Neale
Founding Editor Charles Brasch (1909–1973)

Cover: Sharon Singer, *Pet Voyager*, 2018, acrylic and oil on board, 400 x 300 mm.

Published with the assistance of Creative New Zealand.

creative
nz
ARTS COUNCIL OF NEW ZEALAND *TOI AOTEAROA*

OTAGO UNIVERSITY PRESS

CONTENTS

EMMA NEALE

Charles Brasch Young Writers' Competition 2019 Judge's Report

Some tasks are supposed to get easier with repetition. I thought judging the Charles Brasch Young Writers' Essay Competition would be one of them. So there you go, wisdom doesn't always come with age. A sizeable proportion of the writing in this year's competition demonstrated the opposite. Perceptiveness, sagacity, empathy, good judgement, acuity and achieving a balanced, sombre overview could all be close synonyms for youthfulness, if the entrants to this year's prize are an indicative sample of Generation Y. Generation Y don't you listen more closely, Y can't you see the devastation in front of you, Y are you still pursuing the same methods, Y don't we implement fresh, nimble solutions?

The directness and despair in some essays over what future the planet has brought me close to tears. The issue of climate change often filtered in to discourse that was ostensibly about other things; as if it's now a form of soul tinnitus, always there, just sometimes less intrusive because another area of challenge or complexity also needs our attention.

Yet the primary topics of entries this year still travelled a wide span: from living with obsessive compulsive disorder to the anger and exhaustion of dealing with open and covert racism; to discussions of particular plays, films and poets; from a child's first encounter with the concept of suicide to an extended poetic riff on sunlight.

This competition is judged blind, so I was astonished to find out that two authors have been, or are, students at Northcote College, and our winner is from St Peter's College. I'd assumed at least two of the winning titles were from tertiary students. At OUP, we all hope that both schools' teaching staff carry on doing whatever they are doing to produce such confident, compelling, distinctive voices.

Third place goes to **Hannah Sieberhagen** for 'A Vegetarian, Feminist, Socialist Freethinker Campaigns for Safe Sex, in a Pair of Men's Boots'. A concise, chatty biography of Ettie Rout, the early twentieth-century sexual health pioneer, this essay manages to interleave facts and a clear timeline with gently understated notes of comedy, showing a developing sense of how to help a contemporary reader slip into history's shoes, and so more fully understand past challenges.

Second place goes to **Ruby Macomber** for 'Conversation with Immortals'. This work of creative non-fiction merges memory, imagination, and an appreciation of figures from art history. There is some stunningly evocative writing here that conveys a sparkling cast of mind, extraordinarily sensitive in its observations, responding to visual art as potently as if the painters discussed are beloved ancestors or spirit companions, as well as intellects and artists tackling vexed social problems of their own epochs. Prismatic, elliptical and beguiling, the prose would have leapt into first place with a closer edit for tightness and clarity. This writer shows breathtaking potential.

First place goes to **Jack McConnell** for 'The Taniwha, Moderation of Our Human Pursuits'. This essay quietly marshals historical evidence from written sources in lucid prose, establishing an argument in an almost subliminal way. I wasn't entirely sure, on first reading, which way the taniwha would turn – so the moral flicker in the tail at the closure comes as both a surprise and yet also a satisfying fulfilment of the points carefully, unemphatically, laid out before us. Small narrative florets of legend and history are bound together into a circlet that closes with an elegant return, in a line fusing poetic image and a proverbial tone, to the essay's initial capsule of history and myth. Clustered with informative detail, this essay was also structurally, technically and stylistically the work that maintained the most poised control of all the entries submitted.

Jack wins $500 and a year's subscription to *Landfall*. His prizewinning essay follows.

JACK McCONNELL

The Taniwha, Moderation of Our Human Pursuits

Our ancestors tell us the taniwha does not appreciate ignorance.

In 1876, at Waipapa, four girls sought refuge from December heat in the waterhole. As the girls began to bathe, bold Mereana saw the rātā trees upon the other bank. The striking red flowers were laden with the favourite prize of the tūī, sweet nectar, but they were sacred, and untouchable. This did not deter Mereana, who pulled herself up on the rocks and began to drink what was forbidden. She slipped. The water of the calm pool was thrown about, whirling where she'd plunged in. Mereana's friends dived to find her but, in a few seconds, she was lost. The taniwha Tāminamina, offended by her ignorance of the sacred trees, had dragged her into the depths. This is what happened according to Mohi Tūrei, who reported it to the newspaper, *Te Waka Maori o Niu Tirani*.[1]

In 1907, at parliament in Wellington, James Carroll presented the Tohunga Suppression Act. A tohunga functioned as a priest and healer for their iwi group. Lore gave the tohunga, a figure of significance and history, powers over the local taniwha. The bid to eliminate traditional Māori culture and replace it with modern medicine was driven by frustration with regressive Māori healing, and concerns that spirituality was being used to serve scams and ulterior motives. Upon establishment of the act, any person who practised superstition or claimed knowledge of future events was liable for prosecution.

In 2002, in Kaikohe, protesters occupied a Ngawha construction site. This site was to be the location of the Northland Region Corrections Facility; however, there was opposition. Takauere, the local taniwha, who manifests as either an eel or log, was unhappy. A declaration by the protesters outlined how the construction encroached upon the territory of Takauere, strangled his waterways and prevented him from travelling through his domain. The declaration was supported by Te Taumata Kaumātua o Ngāpuhi nui-tonu, the Council of Māori Elders, and as reported by the *New Zealand Herald*, the

protesters were willing to stay 'as long as it takes' to have their concerns recognised.[2] Opinion around the country was divided: regressive Māori attitude, some argued, was once again refusing to accommodate progress or was trying to acquire compensation. The protests would eventually come to nothing. Northland Region Corrections Facility opened in 2005.

A long time ago, at Ōtautahanga pā, Takere-piripiri the taniwha defended the Ngāti Raukawa tribe. Ōtautahanga was an extremely prosperous pā due to the protection of the taniwha. As such, the iwi's tohunga would ensure a basket of the best food was regularly placed at Takere-piripiri's cave. There came a day, however, when the wrath of Takere-piripiri would come upon the tribe of Ngāti Raukawa. The people responsible for the delivery of his basket, this time heaped with delicious eels, had eaten the food and left Takere-piripiri with only eel heads. Takere-piripiri devoured the people who'd taken his food. The taniwha then abandoned the tribe.

In the 1930s, in every lake and river, a slaughter of longfin eels began. The Acclimatisation Society, in pursuit of higher game fish numbers, attempted to remove trout's predators from the waterways. Large bounties were established, and massive numbers of eels were eliminated from their habitats. Carcasses were left to rot along the riverbanks. Though culling would cease, this had little to do with an understanding of ecological fragility. A more likely factor was the increase in the commercial value of the longfin. Fishermen now harvest up to 495 tonnes of eel each year.

In 1967, in Matahina, the largest earth dam in the North Island was commissioned. Bill Kerrison noted the immediate effect: 'When Matahina Dam was first put in, the place was just absolutely black with elvers trying to get upstream.' Young eels who'd travelled from the Pacific Ocean found their way to the lakes and rivers of New Zealand obstructed. Remarkably stoic, the elvers went 'straight up the dam and across the main road to the lake'. The majority perished. Kerrison stated, 'as soon as it got sunny, they dried out and died'.[3] A poorly constructed fish passage was later implemented, with little effect. More significant was damage to the population of migratory females who left the lake. Having outgrown their freshwater habitat over a period of at least 80 years, they felt the call to migrate to the ocean and spawn. Dams cut these plans to shreds. Power station turbines were too fast, the female eels were too long, the chances of an adult eel surviving passage through a

dam were nil. And yet New Zealand's largest hydroelectric station forms an exit of Lake Manapouri in Fiordland, the location of New Zealand's largest unexploited longfin eel population. Hydro companies suggested the Waiau River exit be used instead.

Centuries ago, at te Whanganui a Tara, two taniwha yearned for the sea. Ngake, the energetic taniwha, and Whātaitai, the lazy taniwha, had outgrown their habitat. It was too cramped and te Whanganui a Tara was cut off from the sea. Ngake, one morning, finally decided to break free of the lake. Coiling his tail against the rocks on the north side, he flung himself against the cliff face to the south. The force of the enormous taniwha destroyed the cliff face, creating a passage by which the bruised but elated Ngake could slip into the sea. Whātaitai decided he must follow. Imitating Ngake, Whātaitai sprang towards the cliff face. This charge, however, had little of the power and energy of the first. Whātaitai had always preferred to laze in the river, while Ngake swam and thrashed about chasing fish and making waves. The tide was out and as Whātaitai entered the gorge formed by Ngake's escape his belly scraped along the rocks. When the tide came in, it was not enough to move the gigantic taniwha. Whātaitai's scales were dampened and he was fed with fish, but he was stranded. After some time, there was a disturbance on the seabed. An earthquake threw the taniwha up, above the water level. Whātaitai, unable to move and now upon a mountain in the air, knew he would die.

In 2002, in Meremere, the course of river and highway was shaped by a taniwha.[4] Ngāti Naho hapū warned Transit New Zealand of Karu Tahi, the one-eyed taniwha, and inhabitant of swampland which an expressway was to pass through. They argued the construction of the road must be halted as it angered Meremere's metaphysical resident. Chris Allen, director of Transit, explained they'd had several other taniwha mentioned but 'this is the first time we've heard about this one'. Ngāti Naho entered negotiations with Transit and a compromise was found. Eventually it was decided the expressway would be diverted around the swampland. The taniwha would be left in peace.

In 2011, in Auckland, the elephant in the room was a taniwha. Glenn Wilcox, who sat on the Māori advisory board, brought up Horotiu, in response to plans to extend a railway through his territory. Malcolm Paterson

defended the call for taniwha consideration: 'Taniwha is a term used in a variety of ways ... Taniwha can be used to mean "what's the issue, what's the potential problem, what's the elephant in the room".'[5] By examining the taniwha, Paterson believed, further issues could be revealed. Michael Laws made a very different response: 'Taniwha do not exist. They are cute, cuddly legends – a brown fairytale. They belong in the same realm as dragons, leprechauns and the fairies at the bottom of the garden.'[6] Laws saw it as outrageous that the taniwha can 'intrude upon the public' and called for an 'exorcism from the mainstream', a removal of Māori misinformation.

These moments considered, do the taniwha stand in the way of progress? And should they?

In 1930, after the cull of longfin eels, unsustainable numbers of trout destroyed the quality and size of the game fish population.[7]

In 1971, after the commissioning of Manapouri hydroelectric station, it was discovered more than 40 per cent of breeding females failed to locate the natural exit and were killed by the dam.

In 2004, 14 months after the completion of State Highway One, unseasonal flooding destroyed the area originally planned for the motorway. The diversion made to avoid the taniwha swampland was untouched.[8]

In 2007, five years after construction was protested, the government admitted Northland Corrections Facility was sinking into the ground. The foundations were unstable.

So perhaps taniwha do stand in the way of progress. But if they do, it is to moderate our tendency to drive ourselves to disaster. Regardless of their origin, regardless even of their status as metaphysical beings or otherwise, their warnings are a call to examine the consequences of our actions. Do not be bold enough to drink the nectar of the rātā flower, if a taniwha tells you not to.

Notes appear on page 179

Bad Girls

I probably would not remember Faith had she not been dead for most of my life. My recollections are slight and shadowy: a fleeting presence in her parents' house; the dark, straight curtain of her hair spilling sideways as she leaned into her younger brother's room where he was showing me a game. Faith's mother was the receptionist at my father's surgery and, very occasionally, she babysat my sisters and me. Though I only caught brief glimpses of Faith, I looked on her with the same quiet awe with which I regarded all teenagers in Westport. Teenagers wore cryptic T-shirts that said things like 'Talking Heads' and 'Simple Minds'; they yelled interesting insults like 'drop kick', 'gag me with a spoon' and 'eat shit and die'. Where I was reduced to a teary wreck in the principal's office for defying the Form 2 bus monitor, teenagers seemed capable of breaking all kinds of rules without regret.

Faith had learnt tap when she was younger, and her mother gifted me her old shoes: black leather with a clunky heel, and two round eyelets for laces on each shoe where the leather was cut into curves. In Faith's tap shoes I tapped my way to second place in a competition class that included only me. My comments sheet was returned with various suggestions for improvement from the chief judge: 'SMILE! Good girl. **NO** brown laces!' Faith's shoes had arrived at our house without laces, so I knew the last instruction was the fault of my parents. Faith's were the only tap shoes I owned as a child. I must have outgrown them before she died or I am sure I would have kept them, or returned them to her mother.

Westport was likely a remote kind of hell for teenagers in the 1980s. All the things that seemed important—bands, actors, fashion, concerts—the kinds of things that featured in TV annuals and *Smash Hits*—these were all somewhere else. Westport's remoteness was such that when I was six years old, a boy brought a photo of a traffic light in Christchurch to school for 'news'—a morning ritual where one presented interesting and remarkable

things to other classmates. I once presented a very large spider in a jar and told the class the extraordinary fact that my father had captured it without any clothes on; another boy brought in his grandmother's freshly removed gallstones. But the traffic light—we gathered around it oohing and aahing thinking that Christchurch must be just like the movies.

When I was eleven, a year or so after my family and I had moved away from Westport, I would receive letters from my old best friend about school camp and 'pashing' and sharing sleeping bags with boys. Informed by my mother that this was disgraceful behaviour, I wrote back with faux sophistication, 'My friends here in Waikanae are far too mature to be pashing or sleeping near boys,' and our correspondence ended.

The same impulse that led my old best friend to get up to hijinks beyond her years was probably similar to the one that led Faith to hitchhiking. In the early 1980s she was known to hitch regularly from Westport to Christchurch: from Inangahua to Reefton to Culverden and over the lonely expanse known as Weka Pass, a place where bizarre rock formations emerge from green paddocks like giant sea creatures surfacing for air.

I recall very little of the day my family learned what had happened to Faith, only the hushed tones of adults, a low and muffled whispering clearly intended to exclude children from the conversation. And yet someone must have told us that Faith had died, and that this had happened because she was hitchhiking. For months there were stories about her in the *Westport News*. These were accompanied by a small black and white image of her face. I stared at Faith's photo, thinking that if I looked hard enough it would reveal something about her life story—that in a kind of palmistry, I would find the truth of what happened to her somewhere hidden within it. I thought the same about the portraits of other dead people who featured in the news—that their photos possessed some kind of extra quality that revealed they were going to die early. I worried about whether my own photos contained these terrible hidden cues, whether images of me were like the Victorian spiritualist photographs in my parents' books where a ghost passes silently in the background unbeknown to the subject, who smiles cheerfully at the camera.

Not long after Faith's death, my parents arranged for our neighbour to drive my two sisters and me to school. Our neighbour was the school dental nurse, whose laughter seemed reserved for the times in her clinic when she

placed her whirring cleaning brushes against the roofs of our mouths as we tried to voice our objections through the cotton swabs stuffed into our cheeks. My memory of that morning is vivid—we pile into our neighbour's car only to have it expire five minutes into the twenty-minute journey. It splutters to a halt in a deserted place where the vast green of empty paddocks spreads uninterrupted into the distance. We exit the car and make our way up an arduously long driveway to a farmhouse bordered by black pines that make a mournful sound as the wind drifts through them. After a fruitless five minutes of knocking, we give up and return to the side of the road. Our neighbour then instructs us to put our thumbs out. I explain solemnly that we are not allowed to hitchhike and that people who hitchhike are killed.

'This is different,' our neighbour assures me. 'It is an *emergency*.' Her voice lingers on each syllable but I remain unconvinced. 'Your parents will understand.' Her tone is now sharp and forceful, as if she is losing patience. A truck appears in the distance. It slows as it comes closer, finally pulling over just a few metres from where we are standing. The driver, a man who looks close to the age of my father, rolls down the window and talks animatedly to our neighbour as I fidget and tremble. Our neighbour gets into the truck with the man and my sisters. I remain on the roadside fussing and procrastinating until she orders me to get in. As I clamber inside, I notice the bright red of the vinyl interior. I do not fasten my seatbelt. Instead, I hold my hands flat and splayed out like starfish to conceal their violent shaking. I know the man is about to drive us off the main road into the depths of nowhere and murder us. The red vinyl is clearly a deliberate strategy to conceal the blood of hitchhikers. The places we pass—the cement works, Carters Beach, the flooded river churning with silt—usually so unremarkable and familiar, become dreadful and ominous. I quietly count down the moments until we are murdered. Then the truck stops. To my amazement, we have arrived at school alive and before the first bell sounds.

I never hitchhike again after that. Unlike Faith, my teenage self is neither rebellious nor brave. Instead, I define myself by sticking to rules and being supremely unadventurous. At college I studiously allocate each hour after school to learning some subject or other. My paintings in art class are defined by a hesitant impressionistic, almost pointillist style, every overlaid brushstroke having the potential to be better, more accurate, more pleasing,

and (most importantly) allowing me to cover up my inevitable mistakes. I do not question the domestic laws of my family, particularly how my mother, who has two jobs, serves my father whenever he hollers 'Cup of tea!', which he does with alarming frequency.

My older sister and I experience the same punishments for transgressing boundaries. My father's preference is for a combination of sending us to our rooms and silence. If we displease him, he might refuse to speak to us for days. Being sent to one's room is an altogether different kind of discomfort. Somehow it drains every toy, every book of its attraction. I imagine how my room would appear if I did not know I was confined to it. If I chose to remain in a room and was unaware I was locked in, wouldn't I feel as if I were free to do whatever I wished, including exiting the room? Overcome by the boredom of it, I try even harder to conform.

My older sister is different. She refuses to study for exams, smokes cigarettes in her bedroom, sneaks out to meet boys, defies my father to the point of being thrown out of the house at sixteen, leaving our despairing mother to organise her accommodation and food without our father's knowledge. Because she is in a band, my older sister has ready access to all sorts of law-defying materials: cigarettes, alcohol, marijuana. She also hitchhikes.

Meanwhile, in my late teens I earnestly follow the warnings about walking home alone in the dark on the university campus, not aware of any of this affecting my freedom.

I periodically think of Faith at this stage, but more in my twenties when I find myself in libraries with microfiches and time on my hands. I sit in the quiet of the New Zealand Room, trying to do university work but finding anything else more interesting. I flick through day after day in the *New Zealand Herald*, the *Dominion*, the *Evening Post*, becoming dizzy from the blurred screen as classifieds, sports pages and advertisements whizz past. And then I find it—Faith's death spelt out in headlines: 'Murder accused to be questioned about a second body', 'Hitcher's body found stripped', 'Hitcher's death pondered', 'Rape-murder charge heard', 'Dead hitchhiker had been hit by vehicle, court told', 'Guilty of murder', 'Rape and murder lead to second life term'. As I read, I remember one of my mother's friends suggesting that the man's sentence was such that he would likely be released after six years.

One article in the *Evening Post* refers to Faith several times as a 'girl hitchhiker', calling to mind the adverts that ran on TV in the 1980s, and the bumper stickers that emphatically announced 'Girls can do anything!' When those adverts appeared back in the early eighties I remember thinking 'Everyone knows that!', despite my resolute deference to authority of which I was not yet consciously aware. The mere existence of the adverts somehow called the freedom of girls into question. More than this, what happened to Faith and the other girls who made the headlines in my youth showed me girls could most certainly not do anything without there being dire consequences: on 1 September 1983, at around 3pm, a fourteen-year-old girl could not return from riding her horse near the Tutaekuri River in Napier; on the morning of 19 June 1987, a six-year-old girl could not get home safely after walking alone around the suburb of Maraenui in Napier; on 26 May 1989, at around 7pm, a thirteen-year-old girl could not bike back to her house from a dairy in Taita, Lower Hutt. This all cemented in my mind the importance of being unadventurous, despite the defiance that defined my childhood heroines: Anne of Green Gables, Harriet the Spy and most especially Elizabeth Allen—the lead character in Enid Blyton's book series *The Naughtiest Girl in the School.*

It's strange how the dead seem to have an afterlife in the things we discover about them, as if what we find after their deaths were part of their ongoing narrative, a posthumous action in a story that has already stopped. A friend tells me of the letter his wife hid in a book before she died, and how she knew that when he next picked it up, he'd be ready to read her words. A colleague left work suddenly after being diagnosed with a terminal illness. For weeks after her death, her out-of-office email message returned the words 'I hope to be back soon', as if sending a dispatch from wherever she now was.

In my searches for the traces of her life, I find that Faith was a postal worker, and that she was nineteen when she died. From looking through electoral rolls I discover there is a man living in Auckland who shares the same distinctive name as the man found guilty of murdering Faith. I search his name online. The man has a wife and children. When I search it again several years later he is no longer married. He has changed his job description to 'dishy'. He posts motivational messages on Facebook. He finds God. For years, there is nothing outside the paper pages of old newspapers about what

he did to Faith in 1985. Then one day the internet catches up, and what he did becomes visible to the world, as if those once silent, pre-internet decades had suddenly decided to speak.

Before Faith was struck by his car, the man had earlier shot and killed a young man in Weka Pass and taken his vehicle. Faith had been making her way from Nelson to Christchurch when she was picked up by the man at Murchison. He drove her some distance and when she exited the vehicle, he ran his car into her. Hours afterwards, in the quiet fields bordering Rappahannock Road, a local panelbeater saw a newspaper blowing against a fence along with Faith's scattered possessions: books, clothing, a cardboard box, a photo album. He called the police and returned the next day with his parents to discover Faith's naked body beneath the bank by the roadside.

The articles in the *Dominion* and *Evening Post* contained scant detail on the trial, noting only that the accused claimed that he killed the young man the day before he killed Faith because 'he wouldn't leave me alone'. As for Faith, he claimed he ran into her 'by accident'. Wanting to discover more, I try to find court records, only to discover that access is restricted for 100 years after the event.

There is a 2010 song by M.I.A. called 'Bad Girls'. It begins with a half-spoken, half-sung refrain that repeats throughout the song's 348 seconds: 'Live fast, die young, bad girls do it well'. I think of Faith when I hear that song, and I think of bad as free, as boundary pushing, as defiance, as that slogan of my youth, 'Girls can do anything'. Back then I did not ask what 'anything' meant. I have vague recollections of adverts featuring women wearing hard-hats as they worked in construction sites, presumably to show that women could work in traditionally male-dominated vocations. But what about existing in the world? Could that same woman walk alone through her own workplace at night without feeling fearful? If she was there after 10pm and someone harmed her, would she be met with the question 'What were you doing there?', as if her choice to be somewhere in the world at a certain time made her in some way stupid, or careless, or partially responsible, as if she could have foreseen what would happen to her, and all she had to do to avoid it was to not be out alone late at night for the rest of her life?

I am still waiting to be brave like Faith, to be someone who more openly takes on 'the rules'. On particularly long stretches of road, the kind where the

scenery is almost luminously green and leads into a personless wilderness, I sometimes imagine I see her—her posture giving away her fierce independence, her hair lifted by the wind, her bag slung on her shoulders as she walks with her thumb out, full of anticipation for her next trip to the city, emphatically doing the 'Anything' we eighties girls were told we could.

My mother remembers hearing Faith's favourite song at her funeral: 'Turn, Turn, Turn' by the Byrds. More particularly, she remembers being upset at its suggestion of the inevitability of the events in life, as if there is set out before us 'a time to every purpose under heaven'.

Almost thirty years after her death, I visit Faith's grave in the Orowaiti Cemetery on Utopia Road just outside of Westport. From the small hillocks you can see the estuary where land, river and sea intermingle. In heavy rain the cemetery has been known to flood, leaving only the headstones visible, rising vertically from the surface as if straining to keep themselves above water. On Faith's grave there is a quotation from 'Burnt Norton', the first poem of T.S. Eliot's *Four Quartets*:

Footfalls echo in the memory
Down the passage which we did not take
Towards the door we never opened
Into the rose-garden.

I lay down a bunch of pink carnations, wishing I had brought roses instead. I look over the fields where a light wind makes small waves of the overgrown grass that obscures the Victorian graves in the older part of the cemetery. For several minutes I watch the patterns, the rhythmic bend of blades, thinking of Faith and the other girls who made the newspapers in my youth, the strange and unknowable unopened doors of their once-possible futures. I look around to see if I am still alone. I take a deep breath. I look around again, then I leave.

AARON HORRELL

The Three Visible Photographs in the House of Old Don Wilkins

Every shipload of guests asks me the same question—How did our human ancestors endure both physical pain *and* the weight of time, when they were little more than hedonistic shaved monkeys? Their primitive biology meant they suffered enormously; surely this gave them resilience and insight into things we cannot know, and a deeper and richer existence. Surely it helped them face the inevitable end of the universe without fear! But after thousands of simulations we have reached a clear conclusion: physical pain neither ennobled nor enlightened Earth-era humanity. Their pain caused them great misery, and we are lucky not to experience it. The truth is, most of our ancestors did not think much about the ultimate end of the universe. And those who did were usually quite miserable.

Our guests do not appreciate this answer. They flap their appendages in disgust and disappointment, then depart for the more satisfying parts of the simulation centre where they bury their fear in the potent early human emotions. Fury, mourning, xenophobia, the experience of going viral, and secret sexual pleasures. They marinate in simple emotions on enormous scales and produce thick stalactites of greasy saliva. They skip across the great Earth empires—the Mongols, the British, the Russo-Soviets, the Panamanians—and they lose sight of the complexities of early human feeling. But by running over all of human history, they only increase their awareness of time, and thus their fear. They intensify the very feeling they came to understand, but learn nothing. And, what is more, they create an occupational safety and health hazard with their slippery slobber.

If we want to understand Earth-era humanity and the nature of our vestigial fears, we need to understand our ancestors deeply and without the distraction of linear time. This means stopping the clock entirely and focusing on single beings in single moments with complex emotional blends.

A Panamanian lieutenant farewelling her former mother-in-law at Oslo International Airport with a combination of love, gratitude, sorrow, guilt and regret. Or a Chilean academic finding his wife in bed with his student and responding with surprise, anger, panic, arousal and shame.

By stopping time and exploring such singular moments, we believe we can understand the last of our emotions and find a path beyond our final source of suffering—the fear of time.

Let us begin.

Please mind the saliva.

It is 9:17am on Saturday 6 September 2014, and something is very wrong in the house of old Don Wilkins. There is no Radio New Zealand broadcast playing in the kitchen and no cup of Earl Grey steaming on the table. There is no soggy newspaper with a half-completed crossword and no sticky butter knife stabbed in a pot of jam. In fact there is no Don Wilkins. Both Don and his dog Barnaby are missing.[1]

The back door of the house and garage door are both open. A rifle is missing from the garage.

There are three visible photographs in the house of old Don Wilkins. With the help of these photos we will understand what Don Wilkins has done, and why.

Our first simulated witnesses are three men who consume alcohol with Don at the Red Lion Inn.[2] The gentlemen say, 'Don's a good bugger.[3] But he's as tough as nails; he's not the type to have photos. They must belong to his bloody ex or something. But … Don should be home at this hour. And where's old Barnaby?'

We thank the gentlemen for their contribution. They are at least half correct: Don does not normally display pictures, but the three photos are his nonetheless. In fact Don Wilkins has two whole albums of photographs hidden in the bottom drawer of his bedside dresser, one with 'Damon' written down the spine, the other with 'Sarah'.

Don's house has two bedrooms, one with a single bed and one with a double. The single bed has not been slept in and the second is missing the top sheet.

Can you guess which bed Don normally sleeps in?

Surprisingly, it is the single bed, which is also the location of our first visible photograph. The double bed has not been used in many years.

The First Photograph

The first photograph is lying on the duvet, face up, with torn and frayed edges that suggest it was recently enclosed in a frame. The photo is as large as a human head and shows a younger version of Don dressed in a brown tuxedo, standing beside a young woman in a white dress. They are both smiling and holding a knife, about to cut a large white cake. The woman's dress is loose and purposefully vague about the state of her uterus.[4]

In the picture, Don is wearing a plain gold band on the ring finger of his left hand.

The photo is sun-bleached down the right-hand side, but it should have more overall fading based on its age. It looks as if it has sat in one sunny spot for several years, then been put somewhere dark for several decades and only recently removed from its frame.

That is the first visible photo.

Before we move on to the second, a brief clarification: apart from the open back door and the living room (which we will discuss soon), the house is typical for pre-Panamanian New Zealand. It is a two-bedroom bungalow with a well-tended garden and a garage attached to the house. But there is something strange about the garage. Can you spot the unusual aspects?

Correct, Don is not in there. But look more closely.

Look at the door of the rifle cabinet.

Yes, that is correct. It is unusual to see empty alcohol bottles and spilled bullets beside the cabinet.

But otherwise, the garage is normal. One side has a work bench and a wall of tools, and the other has a parked Toyota Hilux. The vehicle's keys are in a plastic bowl on the kitchen counter, with $3.80 in change, a few old receipts, and the plain gold band from the photo.[5]

Things are also unusual in the living room. Can you spot the unusual aspects?

Correct. The couch should not resemble a bed. It should not have a sleeping bag and pillow and a pair of worn-out slippers.

On the arm of the sofa we see a notepad with a page ripped off. There are

faint indentations on the paper. If we zoom in and highlight the impressions, we see 'Damon 027 899 8720'.

Note also the mat by the fireplace with the flat spot in the middle. Beside it there is a dog's water bowl with 'Barnaby the bodyguard' hand-painted on one side.

But none of this reveals the whereabouts of Don Wilkins or his dog. That is why we must now inspect the second visible photograph, which sits on the bedside dresser in Don's bedroom.

The Second Photograph

This photo appears to be the most deliberate of the three. It is sitting upright with a thin layer of dust on the top, facing the pillow. The dust tells us it has sat there for many years. This second picture is newer than the first. It shows a boy, perhaps thirteen or fourteen years old, sitting on a grass lawn with a puppy in his lap. The boy is thin and gangly, and through his fringe we can see a low Don-like forehead. He is smiling and wearing a polarfleece sweatshirt with the zip open at the front, under which we can see a black T-shirt with a black pentagram made of bones and the word 'Slayer' in a sharp stylist font.[6]

We call again our simulated witnesses. Gentlemen, who is this boy?

'Ah, that'd be that lad of his. Damon. No job, no girlfriend, hasn't spoken to Don in years. Useless as tits on a bull.'[7]

We thank the gentlemen.

'But hang on there, mate. Where the hell is Don? Is he okay?'

We thank the gentlemen again and turn now to the dog in the photo. Based on the skull shape and the fur, it appears to be a Jack Russell terrier. It is white and brown with thin black eyebrows that make it look as if it is smiling. It has a plastic chew toy in the shape of a human femur.

The surface of the photo is uneven, due to impressions caused by writing on the back. If we zoom in, we can see the words 'Damon + Barnaby 1997' in the top left corner.

That is the second photo.

Continuing our examination of old Don's house, we note the kitchen doorframe. It has several notches that appear to be deliberate, each with a word and number. There are three markings that appear older than the rest.

From lowest to highest they read; Sarah age 3, Sarah 4, Sarah 5. We are advised that these notches indicate the individual's height. They stop at 5.

The rest of the markings are newer. From bottom to top they read: Damon 3, Damon 4, Damon 5, Damon 6, Damon 7, Damon 8, Damon 9, Damon 10, Damon 11, and DÆMON 15. Just below the highest notch we see the faint remains of a black pentagram in the tiny white enamel valleys created by the strokes of a paintbrush.[8]

We proceed now to the third visible photo in the house of Old Don Wilkins.

The Third and Final Photograph

The third and final photograph hangs in the middle of the most prominent wall in the living room. It is hung crooked above a hammer and a box of nails. The photo frame is large, as large as a human head. It is an old frame with sun bleaching down the right-hand side.

Can you spot the unusual aspects of the photo frame?

Excellent. Yes, in front of the photo currently in the frame there are little torn pieces of another photograph stuck to the frame edge. These match the tears on the wedding photo in the bedroom. We can therefore conclude that the first visible photo was removed from this frame and replaced with this new one.

The new picture is small, perhaps the size of a human hand. It shows an elderly brown and white Jack Russell terrier standing on its hind legs and smiling up at the camera. At the bottom of the photo are two feet in a pair of worn-out slippers, Don's slippers. The photo is only a year or two old.

Below the third picture is a small table with a lit candle, a dog collar and an old plastic chew toy in the shape of a human femur. They are placed almost ceremonially, suggesting some form of ritual.

But where are Don Wilkins and his dog Barnaby? And where is the rifle?

We must now look outside the house.

Yes, we see it too. And no, it is not typical. A rifle should not be lying in the grass.

There is a man standing in the back yard beside a lump wrapped in a bed sheet. There is a spade stabbed into the ground and the beginnings of a hole. The man's shoulders are stooped and his head is low.

But if we look closely at the rifle barrel we see no traces of heat or gunpowder. The rifle has not been fired. Thermal imaging reveals some residual warmth on the rifle trigger, as if someone held it for a long time. There are also traces of saliva on the end of the barrel.

We have found old Don Wilkins. And we have found his dog Barnaby, who has died of old age and is wrapped in a sheet, waiting to be buried.

Don has the torn page from a notebook in one hand, with the contact details of his son Damon. Don's other hand holds a phone to his ear. On the other end of the line is a man in his early thirties with a low Don-like forehead. He sits below a Slayer poster, with his head in his hands. A dog needs to be buried, and old Don needs help to do it. And for the first time in years, he has reached out to his son.

That concludes our in-depth look at the morning of 6 September 2014. As you can see, in this section of the park we ignore the sequencing of the human genome and the Panamanian victory at Yangbon. We touch only briefly on the end of sexual reproduction and the first Toyota Hilux. We look instead at a man with too few picture frames, who made the choice to remember his dog and move on from his failed marriage. A man who might one day take those albums of photos of his deceased daughter out of the bottom drawer and put them on the dresser, and maybe one day open them.

And now we have to admit—focusing on this single moment cannot solve the problem of our fear. As long as we are sentient and the universe degrades, there is no escape from time and death. We are right to be afraid. But we should be like old Don Wilkins in the face of fear: we should reach for the telephone instead of the rifle. The end is coming regardless. There is no need to hurry oblivion.

Our fear is not the last stubborn biological remnant of our early human ancestors. There is no cure for the fear that comes from knowledge; we cannot engineer it away. We can only find distraction and consolation, as Don did with his dog and his son. The fate of the universe is an ugly and terrifying thing. We are right to lose ourselves in the present moment and in the people we love.

That concludes our presentation.

Please mind the saliva.

Notes

1. 'Dogs' were a sentient species kept for service and companionship. They were sometimes deep-fried and eaten.
2. Alcohol allowed males to express their emotions freely. It also deferred the shame of honesty until the following day and hid it beneath headaches and rolling nausea.
3. Please disregard the auto-translation; this phrase does not mean 'skilled sodomiser'.
4. The uterus was the primary site of human gestation in the sexual era. Based on the most viewed instructional video clips of the era, sexual reproduction typically involved a young person and a step-parent. For fertilisation to occur, the male ejaculate needs to enter the uterus. However, it was often misplaced. For documentary footage of early-human reproduction, visit our 'Internet Pornography' facility.
5. Gold bands were typically worn by males to indicate 'marriage', a rarely successful form of pair-bonding. Documentary evidence suggests that marriage was a kind of exchange: males provided security for the older females in exchange for access to teenage step-daughters. In return, the older females were given access to groups of well-endowed dark-skinned men. See 'Internet Pornography'.
6. Unlike shirts that read 'Security' or 'Police', this shirt does not indicate the boy's profession.
7. Bulls were male 'cows', a sentient species that were enslaved and killed for protein. The females' 'Tits' were glands that secreted a fatty white liquid meant for juvenile cows, but which our ancestors drank for pleasure.
8. A pentagram was a symbol representing 'Satan', a mythical figure in Christian mythology. Paradoxically, the symbol was used to show rejection of the Christian mythology.

TINA MAKERETI

Pudding

It must be summer. The ground flat and parched; what little grass there is, brown. That's how I remember the farm that whole year, 1983. I think it's summer because I can't remember going to school that week, the week of the pudding. But in fact it could easily have been autumn or spring, those holidays we had in between school terms. The pool isn't there, in my memory. In summer the small round Para pool is always up, its corrugated iron sides interlocked, rubber lining stretched over and held in place by plastic tubing. Big enough for me to swim around and around most days, pretending to be a mermaid, but only the radius of my nine-year-old body, plus a nine-year-old arm's length. Once the green algae start to colonise the pool floor we'll dismantle it for cleaning, pulling off the tubing and separating the interlocking pieces so that the rubber lining sloshes its contents onto the lawn, causing a wide and improbable puddle over the grass until it sinks in. But before the green sets in there are weeks of play, the cool water a welcome respite from that relentless and angry sun, and the sunburn obtained from many hours under it, sunbathing on scorching paths made tolerable by the application of soaking wet bodies.

But the pool isn't there, on the lawn we cross to get to the letterbox, so maybe it is autumn. That makes sense. I feel like there is a too-tight woollen jersey constricting my neck, too high above my wrists. I'm growing fast. No one goes clothes shopping much. Dad's a shepherd, always working and not well paid, though there is the free mutton. The weekends are for watching sport, cigarettes, beer. A man's got to have something. And we have the outside. *Go outside and play.* Though outside is boring. I exercise every ounce of my very active imagination to make it *something.* But that parched earth. No bush. I try to make something of the macrocarpa windbreak, hunt every inch of it for hidden treasures and huts. Try to make the fairies appear, or the pop stars. Either will do.

Every second Friday night there is food shopping and fish and chips in town, and this is the highlight of the fortnight. In town there is the possibility of glamour, even in Central Hawke's Bay. Girls at school have leg warmers and bubble skirts and Wham! records, potent symbols of fashion and the secretive elixir of adulthood. At Lisa's ten-year-old birthday sleepover we discuss sex, what it is and how it's done and the noises Lisa's mother makes while she and her husband do it. Lisa's parents are young and good looking, and that makes it easier to imagine they'd want to do it, but when Lisa imitates the noises I argue loudly that she can't possibly be right. I've never actually heard anyone have sex but logic somehow tells me that it wouldn't sound like that. And then I attempt to make other noises, imitating an activity I have never heard and know little about. No one else says anything but I remember their faces.

I'm not sure if it's then or later that I begin to lose the friends. Early on, when I moved to the area, we are so ardent in our friendship that we whisper 'I love you' to each other in the reading corner at school. But somehow I cannot maintain a grip on these relationships. I can't keep up with the leg warmers and bubble skirts, the baubly hair ties and pigtails. My hair is cut short so that it is tidy and doesn't require too much attention. My wardrobe only grows more sparse, and one day I go to school in bare feet rather than wear the cheap roman sandals my father buys to replace my too-tight sneakers. No one is fooled by this move. Kids' instincts for shame and embarrassment are just too finely tuned. I think even then I understood that they weren't laughing at my sandals so much as my inept attempts to pretend I was something else. This was before all of us were forced into the same ugly sandals at high school. School uniforms kind of saved my life.

Anyway, Friday nights. Food shopping; fish and chips. Even better if we can eat them on the way home, but sometimes we have to wait. The drive home takes about twenty minutes, and during that time I lie on the back seat of our Hillman Hunter and imagine I have the power to become invisible, or to freeze everyone in whatever they are doing. This last is a favourite, but both fantasies have the same objective: power. In such a world, I imagine, I would be able to travel around freely, help myself to all the lollies and all the clothes I want. Live in the best houses. I'd definitely live in town, or somehow go overseas. I'd have to figure out how to drive. And I'd be able to snoop into

people's lives. Undress movie stars. Eat anything I want. Get as much money as I want.

When I felt the need for company again, I would unfreeze everyone and they would find me transformed: wearing the coolest clothes, in possession of large amounts of money, the better to continue my lavish lifestyle. Surely someone with those kinds of means wouldn't even need parents any more. Somehow with this wealth I might also transform my looks: rid myself of the curly red hair and freckles, grow suddenly slender. Annie the musical is huge, and nobody looks more like Annie than I do, but I am not fooled into thinking her charms have anything to do with her looks. I am always dreaming of escape. Always imagining myself away from whatever pain I'm experiencing at the time: rejection, shame, boredom, parental anger, the depths of my own discontent with the world and everything in it.

Sometimes Dad runs out of money completely. This means driving the twenty minutes home on empty. On empty means there is some petrol in the tank but only a little bit so the dial on the dashboard can't detect it. On empty means you are never really sure you'll get home. We always do, somehow. Dad's pretty clever. He turns off the engine and cruises down all the hills. This saves a bit of petrol but there are no guarantees. Over the weekend he siphons a bit of petrol out of the Land Rover he uses for work on the farm. Enough to get the Hillman back into town when he gets paid again. This is when I first learn that a good car, like our Hillman Hunter, will run on the smell of an oily rag.

The particular week I'm thinking of, Friday night shopping doesn't happen. For some reason Dad hasn't been paid. Maybe a problem with the bank. The farmer Dad works for is rich. Not a showy kind of rich, but he can ride out the odd blip in cashflow. He can even ride out the odd drought. He has enough money for a new ute every year. He owns hills and hills of sheep. One day I am allowed to go inside his house and I understand that it is 'old money' that runs his farm. An inheritance. Everything in the house is old, and now, in my memory, it is reddish-brown, the colour of ornate carpets. There are old ornaments in there, grandfather or mother clocks, mounted animal heads. It doesn't seem a place for children, but Dad tells me the stuffed mongoose entwined with a snake that sits in pride of place on a side table represents the story of Riki Tiki Tavi. Do I know that story? No, I don't, I say,

and after he tells me I spend a lot of time wondering how a small mammal can be fast and fierce enough to kill a snake. The farmer has two young boys. One day Riki Tiki Tavi will be theirs.

But we don't have enough money to get through the odd blip in cashflow. Sometimes we can barely make it through a week with expected cashflow, so not getting paid is an issue. Dad gets a roast out of the freezer and puts it in the oven, goes out to give the dogs a run and organise scraps of carcass for their dinner, and thinks about what to do. He's good in a crisis. That's when he snaps into gear. He's not good when he has time to ruminate, too much time to sit in the La-Z-Boy with a drink, too much time to work his way from loneliness to anguish to rage. But when there's a problem to fix he's onto it.

So, there's the roast, whatever is left in the fridge and cupboard, but no shopping this week. Luckily bread and milk are delivered to the gate by rural delivery, along with the mail. A stroke of good fortune the deliveries won't stop and it'll be payday again by the time the bill is due. At least we have that. I don't see Dad come up with the brilliant plan but the next day we're collecting the bread and milk at the gate and using the last of the money to buy up enough sugar, butter and raisins to last a week or two.

'Have you ever had bread and butter pudding, Bub?'

I don't think I have.

'Oooh, it's good. Just made out of bread and butter and milk and sugar and raisins. That's all. Do you want to help me?'

I nod along, and follow him and my big sister, who is always his right-hand man in such daily operations. We butter the bread and layer it with the sugar and raisins, then cover the lot with milk. Bread soaked in milk doesn't look good to me. Do I say this?

'Just wait until it's cooked.' He rubs his hands together. 'It's really good. And guess what? We can eat pudding every day for dinner for the rest of the week!'

I'm doubtful, but something in his voice is utterly convincing. He makes it sound like such an adventure. Bread and butter pudding every day! Pudding instead of regular food? Instead of vegetables? Even if it is made primarily out of bread and milk, this seems like a good deal.

And when it comes out of the oven, after an infuriatingly long time, it is delicious. There is a rich crust, and the milk-soaked bread has a wonderful

consistency, more firm than the instant kind of pudding. The raisins are fat with absorbed juices, and the butter has done what butter does best, infusing everything with rich salty-sweet flavour.

We eat our fill. And eat our fill again the next day. Dad is a genius. Every day he waits to see if the money has come in and when it doesn't we make another pudding and he makes a game of it. By the end of two weeks we've all had enough of bread and butter pudding and I don't think I'll ever eat another one, but it's okay. I don't remember Dad being angry during those two weeks. He was determined to make it fun. We were determined to play along. The world wasn't being kind, but out there—far from everyone else—we were all on the same side. Then the second Friday came around again and there was money in the bank, food shopping, and fish and chips on the way home, cruising down the hills.

LEANNE RADOJKOVICH

On Spinning

A storm hit in the night; terracotta pots crashed across the deck. There was a tremendous crack followed by a tearing sound and a thump and the raw scent of foliage shot through a gap between window and sill. The curtains lifted in waves over my head; I rolled to the far side of the bed. Earlier, I'd listened to a woman who'd escaped from a cult being interviewed on the radio. She'd floated like a spider's thread, she said, settling in a caravan park in Brisbane. I'd been sorting my clothes into piles and only half-listening until then. 'I didn't want to leave my younger brothers behind. That was the hardest part, going alone, in the middle of the night, knowing I might never see them again.' I was about to make a similar journey across the sea, except my brother had left me.

The next morning was calm. Gulls silently circled overhead and sparrows hopped across the lawn. A branch had torn off the gum tree; I dragged it over to the fence. The silver leaves gleamed—hard to believe they'd been dying for hours. Then I caught the scent of a neighbouring pine and flashed back to the day I'd thrown buckets of hot water and disinfectant down the dogshit-encrusted path to my old family home.

I'd been so mad at my brother Brent, his face frosted with stubble, ash-blond hair sticking up as if conducting static—he looked as calcified as those turds. The house had always been a tip so I should have expected it, but he had to be out in three days and nothing was packed. His dog had died a week before and the body was still under a tarp. 'What's the point of burying him? The bulldozers will do it.'

Brent had lived in our house his whole life. All the yards in the street backed onto bush with paths beaten between. There were cricks and bells of birds year round and a mazy hum of mosquitoes in summer. A creek lay at the bottom. It was more of a raggedy line of puddles, and when rain came the puddles joined up and eels slipped by like shadows.

By the time I was seven we'd buried in the bush two canaries, a guinea pig

and a cat. Brent and I wanted to put Mum there too, so she'd stay close. Dad said no, there was a special place for people and that's where Mum would go. Brent was such a sweet little boy, I loved him like a teddy. He'd stood there quietly, wearing his toy sword and pirate hat, then he touched Dad's hand. 'You need a lie-down, Daddy,' he said, and led him back to the house.

Later, we wrapped Mum's heart earrings and a macaroni necklace Brent made at kindy, put them in a baking powder tin and buried it under the flax. Then we rocked back on our haunches looking up to heaven. Had Mum seen? We couldn't tell.

I remembered Brent and Dawn in the sunshine two years later. He held up a bird's nest shimmering with strands of his platinum hair and her orange lengths. She'd decorated the nest for his treasures: a broken cup with the Queen's face on it, a kingfisher feather, a teaspoon in the shape of a cockle shell. He hugged Dawn's thigh as tightly as he'd hugged Mum's, and she called him her human caliper.

Memories like these eddy like autumn leaves. Dawn blowing into our lives—her parents wanted her to have a fresh start and Dad said sure, she could stay and look after us kids while he was at work.

Dawn had a mass of carroty hair, big as a bonfire. Her father had the same fiery hair. When he put his arm around her and squeezed goodbye, her face greyed. After her parents left, Dawn picked up Brent and swirled him around the kitchen singing 'These Boots are Made for Walking'. She wore a jingly charm anklet and a toe ring, and cooked purple-dyed spaghetti sauce and cheese omelettes stuffed with popcorn. Brent and I weren't sure whether Dawn was a child or a grown-up. She smoked stinky rollies and after a while Dad did too. She had a lazy eye—it would swivel to the left when she smoked so I never quite knew where she was looking. Then she got fat and five months later had twins.

In the meantime Brent and I played in the bush. I made forts along the creek's edge, with moats where I floated newspaper boats before letting them free on the current. Brent spent hours watching spiders spin webs. He kept still as a rock because if you moved a millimetre, the spider stopped mid-weave. On foggy mornings the bush glimmered with dew-strung webs. There were so many, hundreds connected with strands of spider silk—we couldn't move without breaking one. At first Brent thought stars had fallen off the sky.

Sometimes we glimpsed a rat slinking between grassy toetoe skirts. Dead rats stunk for a week. We wondered how many bones were in the ground under our feet. Not just our old pets, but those rats, birds, skinks. Sometimes Brent dug holes searching for skulls and skeletons.

Carroty-haired babies came home from hospital squawking like ducks. 'Colic,' said the Plunket nurse. She made notes in her book and asked lots of questions. 'Have you any family support, dear?' The nurse came the next day and the one after that. A few weeks later Dad said he was bloody well going deaf. The nurse said it was time Dawn's parents came down. When the nurse left, Dawn squatted in a corner of the sofa, rocking.

After Dawn arrived, Brent and I had moved to bunk beds in my room. We had a big section and Dad, who was a builder, said he'd add another room. Dawn said she'd plant a garden and grow grapes, herbs, sunflowers. Then they got stuck into smoking pot and nothing happened. After a while Dawn planted a tomato garden behind the house. The plants grew huge with leaves the size of dinner plates—but no tomatoes. She pulled out the plants and hung them upside down in the garage.

When I arrived the spoon and rubber tie had fallen to the floor and Brent was slumped, eyes wide, face stretched back as if he were tearing past on his motorbike. He was scrawny and ill-looking. I knelt beside him and put my head against his arm. I felt so tender, now that my anger had rolled away down the path along with those dog turds.

I remembered the day Dawn breathed dope smoke over the babies' squinched-up faces until they nodded off. Her lazy eye swivelled, she glared at us—so blazed her eye was almost out on a stalk—then she stomped into the bathroom and locked the door. Brent and I waited to see what next. We heard Dawn crack open the window, then nothing. She didn't come out for ages. Maybe she'd fallen asleep in there? I made peanut butter and jam sandwiches and we crept out of the house, going as far as we could to the tallest trees. There was a strange silence: no breeze in the leaves, no birds whistling. We sat on a thick carpet of moss. The babies had cried all night while Dawn and Dad shouted at each other about her parents coming down. Brent had climbed into my bunk and we'd lain together, shivering. Now, sleep-deprived, in some kind of post-twins shock, we sat quietly on the moss

eating our sandwiches mechanically, crumb by crumb.

Something thumped on the ground. We got up to see what it was—Dawn's sneaker. A creak overhead, we looked up and saw her dangling.

I made Brent and me a cup of tea and sat on the back step as the sun sank. 'Come and look,' I said. He shuffled across from the sofa. The sun was a fat orange honey-ball whose rays turned the flax spears into flaming green swords. I saw a crescent moon hanging low in the sky, and I don't know why but I started crying. Brent squeezed down beside me and I sniffed back tears. Birds hooted in dark trees and swallows swept across the deepening blue.

'Come to Aussie with me,' I said. 'We'll have fun exploring.'

'Nah, I'm sorted.'

'Where are you going?'

'A mate's farm.'

'What mate?'

'You don't know him.'

'Then come over for a holiday. Promise?'

'Sure, why not.'

I put my head on his bony shoulder and we watched faraway stars. 'I love you, Cassie,' he said, and I cried buckets—it was the first time he'd said that.

It was foggy when he left the property three days later. The fog may have played a part, police said. His motorbike crossed the centre line and collided with a milk tanker.

I went back a month later. All the houses in our street had been trucked off site, trees chopped down, the creek diverted and filled in. Bulldozers had left a smooth brown field and new sections were marked out with gossamer-like string taut as the frame lines of a web.

I stood on the kerb thinking of everything in that soil: Mum's earrings and macaroni necklace, Dawn's sneaker, childhood pets, Brent's dog.

New houses and families would come; the earth would gather in their offerings too.

CLAIRE ORCHARD

Breakages

Dusting the heart rimu shelves
my father made my mother,
where the Matchbox cars collected
by my brother still live, I wonder again
at the impulse to gather and hold on to things,
even broken things, probing the familiar
sadness. I've looked all over
for the little brass carriage clock
my parents were gifted for their wedding
because the last time I saw it
I enjoyed the way it had begun to display time
in the style of tottering, elderly people:
the second hand decelerated and moving jerkily,
the minute and hour hands often nodding off
companionably together in the afternoons.

Petrichor

that distinctive scent
just before it rains

a word it seems
for everything

the quaint precision
of *poetaster*
 palimpsest

linguistic fondue forks
few still have use for
anachronistic as typewriters
tapping themselves into oblivion
across paper
thin as onion skin

or that heady white
solution used to gloss over
our mistakes.

There's a word for everything
it seems except
what there are no words for

that hush that follows
a heavy snowfall
that loneliness of distant
panes of light
on warm evenings.

We are prisoners
of the realm
of approximation
it seems our lives indescribable

as the elderly Chinese couple
who walk backwards
through the park
he in a heavy parka
even in summer
she tapping her head
her hands birds
pecking at seeds
speaking softly to each other
like distant bells
chiming.

JOAN FLEMING

Alterations

How does it alter you in back of the fat berries of the eyes You want to talk
some story? *They talked to the soakage for water, they been talking* I'm
scrabbling with a hot eyeless capturing lead getting it down 'it' *They dig
for the snake, black head, they call it python* Plenteous pieces of story rent with
travelling *they trying to pull, but it was a rainbow snake* between two tongues
keep pulling, keep pulling, keep pulling and altered as the earthlike tips to astral
sheen *So the rain was heard and got up and drowned the whole lot* the mind
unsnagging a little from its linear wax so viscous *it breaked in half* *they
still do that today* new little holes in the mind Good story

JOAN FLEMING

Papunya is Gorgeous Dirty and I Second-guess my Purposes

Moleskine spool of the guest as she confects her private reek
and calls it research. If it is written down, what then.
Come closer now. Your fridge of neurons prevents you
lying down easy in the shape of their fifth world.
If prick, then the head breaks off—
and there's a spinifex sea to rash up to. What was it
you were hungering in less red distances than these?
Host has a *watiya* splintered by the feet-bones,
you have a plaster the colour of 'skin'.
It hurts but it doesn't stop the work of hunting
in a shared wind blowing forked ways
on your family names. What was it you thought you might
understand? Gaze fixed
on the sewing stick that verses up the underbelly.
Your legs itch as you watch the common grey
experted into the fire, along with her joey.
Tell me how you will write this. Is there still an unglazed desert
and a mob of plunderable humans when you're done?

*The context of these two poems is camp life and bush life in Nyirrpi and surrounds, in the
Central Desert of Australia. This work is a five-year-long-and-ongoing investigation that
has arisen out of historical family ties and close relationships with the author's Warlpiri
friends and teachers. The poems have been written with their collaboration and full
consent, and grapple with the mutual cultural misunderstanding between settler and
Warlpiri worlds.*

The Vitruvian Baby

There must be an algorithm for the twist
in the space-time continuum
when a baby subjugates the room.
I'll have to find a *Dr Who* geek to ask.
My son's living room usually feels spacious,
but, with their new baby spread-eagled
like Da Vinci's *L'Uomo Vitruviano*,
the room seems to have shrunk.
He occupies a space out of all proportion
to his actual size—like the Mekong
ebbing and flowing—so large
they have their own tidal system.
He's absorbing the life-force of his parents.
It drains from them as he transforms
into a mini sumo wrestler while they
become shorter, thinner, tireder, older.
He didn't exist once, a black hole
exploded, and there he was, blinding us
to all but the freshness of him.
I lick his skin sometimes.

The Swimmer

The plane swings in lazy, the words 'Shark Patrol' in black block letters on the undersides of its wings. Alice is bobbing in the shallows, looking up at the Australian sun. She wonders which will get her first, the shark or the skin cancer. She wonders who'd care.

It's hot here, much worse than home. She sweats into her clothes, dark stains in her armpits, sweat in under her breasts that trickles down her body like insects. In the wide streets, the yellow stone buildings are crisp at the edges. So is Alice.

Back at the hotel she runs the bath with cold water and lies in it. She fills up the tub with her body, her breasts and her fleshy stomach bobbing above the water level. It isn't enough to cool her down.

Now, she stands outside the pool door, thirsty for the cold water, for the weightlessness. The pool flickers with the reflection of the water. There's no one in there but there are wet footprints to the door, the water swaying from side to side.

The card key doesn't work. She tries it again and again in the slot. Each time a red light, or orange then red. She pushes harder.

'I can help you.' A voice, and when she looks up it's a girl, with a housekeeping trolley and too much eyeliner. She's pale, gaunt, and Alice wonders if she is sick. The girl slots her own card into the door and it whirs. The door light flashes orange, then green. It clicks open.

'Thanks,' Alice says.

'No worries. Sometimes they don't work. Enjoy your swim.'

Alice holds the door open with one hand, the other tugging her towel around her. The door clicks behind her. The girl moves on down the hall.

Behind the pool door it's noisy. The air-con hums, its industrial vents in the ceiling like dark mouths, the noise growing and fading like the echoes of sirens. The water eddies in the jets of the spa. Somewhere a drip is hitting something metallic.

There's a sign on the wall, its corners screwed into the rust-stained tiles. 'No running, no diving, and no glass in the pool room.' She piles her things on a lounger below the sign: a towel, the door card, a book for the spa. She lowers her body into the cool water of the swimming pool.

Faint trails of bubbles lit up by aqua lights glow under the rim of the pool. She swims breaststroke straight down the middle of the two lanes tiled into the swimming pool floor.

Alice's stomach softens, dropping away from her spine. When she sweeps her arms through the water she doesn't think about the way the fat on the underneath wobbles. The muscles in her thighs tighten and release. She breathes, her nostrils suddenly filled with the smell of chlorine as the air rushes in, and then her face is back in the water, her body pushing her forward.

She goes under, then up. Under, then up. At one end of the pool there is a large clock, its second hand moving smoothly over its face, and she finds it again and again as she surfaces, like a ballerina in a spin. She goes under, then up and looks to the clock, but it is gone.

The water around her glows alien. She pauses, treading water, blinking. There is nothing there. There is nothing on the tiled ground below. She spins about in the water, looking at the walls around her, puzzled. Through the basement windows, the spiky shapes of the ferns, the blades of the flax, are silhouettes against the light.

She ducks under the water, and surfaces, shakes her head. She leans forward in the water, trying to get back into her rhythm.

She turns at the end, looking again, and as she does so she sees the clock, pale and moonlike at the other end, in the spot she was sure had previously had the sign above the deckchairs where she'd left her things. Her towel has been pulled out of her neat bundle, has been flung over the back of the chair.

She calls out, 'Hello?' and the sound hangs above the water while she clings to the edge. Her voice ricochets off the walls, tiled like the subway or a butcher's, echoing, 'Hello ... hellllooo ... heellllloooo?' Her fingers grip the edge of the pool, the small stones gritty and wet.

She shakes her head again. She must have left the towel like that. She's mistaken the clock's spot. It was always down the other end, by the gym. Or it's a reflection. Or it's her.

As she swims, she remembers the shark plane and thinks of sharks, the hunter's body and teeth, the rows and rows of teeth. The thought swirls in the water around her and she panics, kicks out, makes for the side. The water churns white. She hauls herself out, struggling for purchase from the deep water, fighting for the side.

She gets out, her bowels like acid. She picks up her towel. It is wet—dark wet patches from its contact with someone else's body. Her book is lying face down, open, the spine cracking, wet fingerprints on the cover. She turns and looks behind her.

'Hello?' she calls again. She bends to pick up her things. The lights in the hallway flicker through the glass wall. They go out.

Alice's chest tightens and she can hear her breath rasping as though it belongs to someone else. She pushes her card into the door lock. Orange. Red. She does it again. Orange. Red. She looks around but there's no other way out.

She lurches back and sits on the lounger, trying to breathe slowly. She's alone, and it's never felt clearer.

The door lock whirrs. There is pressure behind her eyes and she wonders if she will faint. The door lights flicker orange, then green. The door swings open and a man in a hotel uniform walks in. He wedges the door open and turns to the bin full of wet towels. He spots her, and straightens up.

'Oh, Miss, sorry, we're shutting the pool now. It's 10pm,' he says. And he stands deferentially to one side, his eyes cast down as she raises her wet towel.

'Oh my god, I'm so sorry. I didn't realise the time,' she says, and scurries for the door.

In her dreams there is grey skin in the water, black eyes and teeth, and she's not sure if she's swimming in the pool or at the beach, but there is the grit of sand. When she stretches out across the sheets, her fingers run over the crumbs of late-night eating. On waking, she finds blood on her pillow, and a trickle of blood down her cheek. There is the same iron smell as in her dream. She slept with the air conditioning on again. Her mouth is dry.

She's not used to waking up here; the room feels unfamiliar. The mirror, the window – have they swapped sides of the room? She looks about. Is she in

her own room? The bathroom door is ajar, but surely that's where the kitchen used to be? Yet there on the couch are her handbag and hat. There are the empty wine bottles on the counter, only the counter is not where it was.

She stands up, and staggers, catching hold of the night stand. In the bathroom she splashes cold water on her face. Her skin is red and blotchy under the stark bathroom lights, darkness like bruises under her eyes. Alice rubs them but the darkness stays, even though her makeup is all gone. The bathroom is exactly the same—the same hexagonal tiles in tasteful black and white, the LED lights recessed all around the mirror, the same miniature products on the shelf—only the shelf was surely on her left before. She can picture stretching across her body with her right hand, her dominant hand, to grab her toothbrush off the shelf. She can picture it. Can't she?

There's a knock at the door. She's still wearing her swimsuit and nothing else. The straps have cut into her shoulders, and the elastic at the crotch has left angry red marks where the swimsuit twisted in her sleep.

'Hang on.' She tugs the white waffle-weave gown from the door, fumbling it on.

'Housekeeping!' and already in the next room there's the girl with the trolley and the eyeliner.

'Oh, sorry,' the girl says. 'I didn't realise you were in here. Just here to do the room. Shall I come back?'

'Uh, no,' says Alice. 'No, now's fine.' She pauses. 'Look, is this my room?'

The girl looks up at her, confused. Her kohl-dark eyes draw in tight at the corners.

'I mean, have I been in this room the whole time?'

'Sorry, Miss. I'm not sure what you mean?'

'I guess ... do you always clean this room? I mean, have you seen my things in here before? Have I always been in this room? It seems different.'

'I'm sorry. I just clean the rooms. I'm not involved in room changes.'

'No, I know. Look, I'm sorry. I know this is weird, I just ... I'm just not sure it's not the room I was in yesterday.'

'I wouldn't know—sorry.'

Alice stands aside, tying and retying her dressing gown, as the girl moves into the kitchen, drawing out the rubbish bin, collecting the white bag, the empty teabag packets from the bench, and goes into the hallway.

The thoughts slide around Alice's head and won't stick. Her days in the hotel blur together and she isn't sure when she last drank tea. When she last brushed her teeth. And there's apparently no one she can ask.

There's a buzzing as the girl re-enters her key card. Alice watches as the door lights flash green.

'Anyway,' she says, 'thanks for your help with the door last night.'

The girl looks up at her again.

'I'm not sure what you mean.'

'Down at the pool.'

'You must have me confused with someone else,' the girl says. She looks around and gives the kitchen bench a wipe. 'Would you like more towels for the pool?'

Later, in the evening, Alice takes her key card and walks down the corridors. The hallways are lined with mirrors that warp and bend her reflection as she goes past. In one her body is condensed and her head a pin dot, in another her legs bend back at the knees. In all of them she is alone in the dimness.

She goes down the stairs, walking down the centre away from the solid, turned bannisters. She goes through the door at the bottom, its heavy weight swinging back silently into place as she moves through. She turns to look at it, but it is only a smoke-stop door, no key card required. There is no one else down here—no cleaners or porters, no guests pounding along the corridor. She steps off the stairs and towards the door. She slides her key card into the slot. It whirrs. Orange. Green.

Back in her room Alice fills a water glass with wine, drinks it quickly. There is another glass in the sink that has the grainy marks of dried red wine around the bottom. She wonders why it wasn't cleaned away by the housekeeper that morning. She's sure she hasn't had a drink earlier today.

She rummages for food in the packets on the bench. She takes a bag of crisps and pours them, salty and oily, into a bowl. Propped up in bed, she watches television, chip crumbs spilling down her chest and lying in her outline on the white sheets. On the screen, women with too much makeup covering obvious cosmetic surgery scream at each other. Alice drinks more.

There's a point beyond which she knows she won't be able to keep her eyes open. The wine glass is empty and it's fallen from her fingers, leaning sideways on the bed. The TV has given way to infomercials and she struggles briefly with the remote, finding the right button to turn it off. The television goes dark and so does she.

She wakes up, cold in the dark. The digital clock beside her bed flashes 2.37 and she doesn't know why she is awake. She struggles to shift her body, ease the sheet down under her hips to get into the bed, but as she does so there's a noise, and she realises it's the noise that woke her. A whirring.

In the dark room the lights of the door lock shine bright. They flash red. Orange. Green. The door swings open.

She leaps to her feet. Her eyes are bleary as she tumbles across the room towards the light.

In the doorway the girl with the kohl eyes, her skin grey, her teeth flashing in the neon light, is standing in her housekeeper's uniform. She beckons to Alice, then turns and walks out of the room. Alice tugs on the dressing gown, grabs her door card and follows.

The girl turns a corner and Alice has to hurry, the mirrors flashing reflections at her, her eyes like black holes in her face, but she barely notices. They go down corridors that Alice does not remember, and as she blinks awake she realises she would not be able to find her way back.

But there is the pool door. The door light flashes green and the girl slips inside.

Alice uses her door card. Orange. Green.

The pool room is empty and dark. Even the water is missing its glow. The girl is gone. Alice walks to the edge of the pool and crouches down. The water jostles, washing up over the edge and onto her feet. It's cold and solidly black, and she knows, she *knows* there is something finned and dead-eyed in there. Where is the girl?

'Where are you?' Alice cries out. It seems to her the darkness is growing, becoming darker and deeper. She looks over her shoulder to see the water splashing gently at the sides of the pool, the noise of the filters grim in the background. The girl has gone.

Alice stumbles to the door, brandishing the key card. As she turns it to find

the magnetic strip the card slips out of her hand. She scrabbles at the floor tiles, hunting with her fingers, her eyes fixed on the glass wall.

Then she feels thc smooth surface of the plastic card and stands, too fast, her head dizzy. She jabs the card in the slot. Orange. Red. Again. Orange. Red. The cold brought on by the water is gone and she is flushed. Orange. Red. Sweat prickles under her arms. Red. Red.

She runs to the other side of the pool, to the windows. The darkness swirls and eddies around her like water in the wake of a shark. Through the ground-level windows onto the courtyard outside she hears the faint sounds of a party. She bangs on the glass but it is too thick for her to be heard.

Please, she thinks. *Please* let it be over. There's a splash, and water from the pool surges over the edge to Alice's feet. The water is a maw of darkness; its many rowed teeth and the cold hunger underneath make her gasp. She steps back, her door key clattering to the floor again. She stumbles back further, and slips.

She tries to stand, to pull herself up, but the weight of the darkness seems to hold her down and she finds herself being drawn towards the pool. Soon she is wet, her arms stretched out into the water. Then the rest of her slithers in and she is submerged.

She thrashes about, her blood whirring in her ears, and tries desperately to reach the surface through the gloom, but the water just passes through her grasping hands and there is nothing for her feet to press against ... Soon her breath bubbles out of her and is gone. She tries again but it is impossible. She closes her eyes ...

When Alice wakes up her mouth is dry, even though her clothes are wet, and the damp bedding has twisted around her. She reaches for the glass on the bedside table but it's empty. She untangles the sheets and stumbles to the bathroom. There she refills the glass and swallows fast, the water running out the corners of her mouth.

Leaning against the bathroom cabinet, she looks into the mirror. Water is beading on her grey skin, her teeth are jagged white peaks in red gums and her eyes are ringed with black. She looks like a stranger but it is suddenly clear what she needs to do.

The water is hungry, and Alice must feed it.

JOANNA PRESTON

Allegrophobia

A useful early lesson in the need
to not be late—my own birth,
untimely, ripped from my mother's womb,
yanked into the world
like a rabbit from a hat.

Red-faced and pent-up and starting to cry,
I curse the train delayed on platform eight,
the late dinner guest, the tardy compliment,
the making-up of numbers, dates, and all
the fictional appointments made by plumbers.

But worst, the filibustering arrival
of the spring—a snatched-up bunch
of scrunched-up buds proffered
in its fist, its neck still damp with dew,
a scrap of mist like toilet paper
stuck to its chin.

ROBYNANNE MILFORD

Lady with Lizard Tongue

for Anne Hamblett/McCahon

First-class pass in life
drawing again and again, the art
prizewinner becomes her own stilled
life, retires *between the lives* of a larger canvas
and husbandry, grows, without *a table*
of her own costumes, food, children's
illustration Was it enough to hang up
Flower Piece? Always hung
Reminder Tormenter Tantaliser
Step back three paces, step into
a party Hear toss of heads, a throaty rose, the smoky
banter Lady with Lizard Tongue harangues
some delighted specimen with whipped-up
hair, while lounging legs of men look on wondering

Flower Piece, 1939, Oil on board. Known to family as 'Lady with Lizard Tongue'

SHARON SINGER

Everyday Calamities

1. *The Seekers' Circle*, 600 x 450 mm
2. *Night Picnic*, 450 x 630 mm
3. *We Have Come a Long Way*, 600 x 910 mm
4. *Burn Brighter*, 500 x 400 mm
5. *The Good Gardener*, 450 x 450 mm
6. *The Case Against Octopus Farming*, 400 x 500 mm
7. *Where You Gonna Run To, Downpressor Man?*, 760 x 760 mm
8. *Pet Voyager*, 400 x 300 mm

(All works acrylic and oil, 2018)

Sharon Singer's work both beguiles and confronts. The bright, lolly-scramble oil paints, layered over acrylic or watercolour, draw attention like carnival lights. Yet they assemble into scenes with unsettling disconnections, a sense of the improbable, which nevertheless leave the intuition that difficult truths have slipped in on needles of wit.

A surface harmony in the work is disrupted by surreal juxtapositions. It's a catalogue of lucid, yet uncanny dreams: a pink sun (filtered by pollution?) belying the Eden green of the slopes below; the black lips and drugged, doll-like stupor of a girl watching a fire-breather near incinerated trees; the extinct blue macaw and a vanquished man in a work that envisions a vivid alternative reality. If Singer's earlier work based on fairytales sought to expose the violence in that genre, this series of sci-fi scenarios unveils the bizarre in fantasies—of humanity either colonising Mars or carrying on blithely on the home planet we're destroying.

Is it more absurd to transport an octopus to the rust red, iron-loaded soils of Mars and plant dahlias in its cold desert, or to continue, as we are, Mona Lisa-smiling in resignation at climate crisis? Singer's work yearns for a marriage between optimism and creativity, and an environment that can withstand us. Yet simultaneously it plays the wise jester, shaking its toetoe stilts to wake us out of our utopian reveries.

— Emma Neale

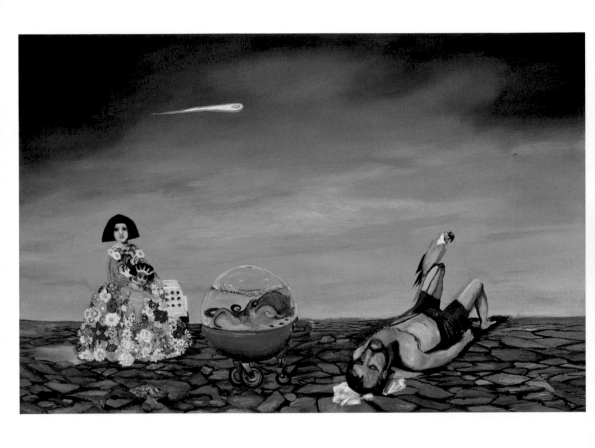

RACHEL O'NEILL

The Supernatural Frame

You may look upon the painting through these special foiled binoculars. We are at a safe distance. Afterwards you may feel a chill or a fever linger for two days and a night, accompanied by an infernal cough. This can only be overcome through treatments of the chemical element of atomic number 16. A recovery ward has been added to the gallery from which our observations take place. Yes, it is a sort of sanatorium or spa, a wondrous bubbling place, with a trauma ward. Will it be worth the cost? 'If I could look again I would,' is the usual reply from those who dare to peek at the most hellish painting in the world. Yes, you could call it an involuntary wail. Well, I couldn't say for sure, though it's likely to be the sound the soul makes as it touches its own extremity, recoiling bewildered from the supernatural frame.

RACHEL O'NEILL

The Hungry Virgins

It's true I did lead 11,000 virgins on a pilgrimage to Rome without thinking about how I was going to feed them. Who' says virgins lack appetite, especially on a long march. Anyhow, we get by. Somehow. No one likes to see a pack of hungry virgins on the prowl, especially given the incredible rumble they make en masse. Today we came to the ocean and bathed. The local fishermen were not impressed. You virgins chased all our fish away! Everyone had to settle for dry salted cod. The fish returned to the nets a week later. We receive many thankful messages from the representatives of towns we vacate, that is when pigeons can be blindfolded or tricked into flying over what town criers have taken to calling 'the angelic salivation'.

CAROLYN DECARLO

Winter Swimmers

Shivers pass through their fingers,
the winter swimmers
anchored below.

They gaze up from their places
in the gelled silence,
bodies swaying—
unweighted, suspended.

We drift on the surface,
obeying the currents
all snorkels and goggles
fogged up in excitement.

It is a privilege to lift
our toes off the sandy bed
and not grow roots,
buoyed by saline,
oxygenated sacs
hanging at our ribcages.

They have been before us,
the winter swimmers,
and left long ago
below, in quiet places.

Our feet brush against their hair
as we kick on,
bending back to flip

over and over, never tiring,
eyes open to the light
playing fractals on the surface.

We have gone far,
chasing brightly coloured scales,
the shore a thin strip
tearing open the horizon.

We cannot guess the depth,
diving down to cup the water,
pushing it behind,
catching—
just for a second—
a white glint beyond the deep.

JOHN GERAETS

Ruth Dallas–Turning

It is the centennial year of Ruth Dallas's birth in Invercargill in 1919.

I want to speak about Dallas and New Zealand poetry, but before stepping forward into that topic let me for a moment step back into a broader historical consideration. 'Canonicity' has become a bane.[1] The received notion that literature is self-authenticating has been proved erroneous. More and more we appreciate that the very prospect of stability is up for grabs, in everything. Explanations of continuity and of an agreed order apply only in retrospect. They are not self-evident. With this thought in mind, let me say that while I continue to have some reservations about the following study, its purpose remains clear enough. It is twofold: to give Dallas her due as a poet, and to argue a living place for her in our literary heritage.

Relatively the most published poet in Charles Brasch's *Landfall* (1947–66), Dallas now goes hardly noticed outside the straightforward appeal of school magazine poems like 'Milking Before Dawn' and 'Photographs of Pioneer Women'. Nor is it obvious how to incorporate her within more recent nexus based on gender, ethnicity, ecology, avant-gardism, faith or political affiliation. One of the reasons she lacks favour is because we are bereft of a serviceable framework within which to accommodate and assess her work.

In what follows, the text in the left-hand column is based on the *Landfall* editor–contributor correspondence,[2] or is Dallas in her own words, from *Curved Horizon: An autobiography* (OUP, 1991) (hereafter *CH*). In the right-hand column is a contemporary evaluation of her achievement as a New Zealand poet.

<p align="center">*</p>

I simply responded to the poetry which I felt already existed in the landscape and the people of Southland (CH, 111).

★

Having seen only a few of her poems, Brasch invites Dallas in 1948 to choose six for a proposed 'under-thirty' anthology. His initial enthusiasm is confirmed: 'I think these poems will make a very good group, true and individual work' (5 August). In deference to editorial guidance, the opening couplet in 'The Boy on the Rock':

> Returning, their laughter under the
> sound of stones
> The sea had rattled loosely as lightly as
> bones

becomes

> Returning, after the wind, and sea that
> had boomed
> And roared among great rocks, their
> laughter seemed

'This is what I needed,' she explains, 'to have things pointed out' (17 September 1949). Of 'A Striped Shell' Brasch cautions, 'it might be wise to avoid words like "strange" and "mystery" when it's strangeness and mystery you are trying to convey.' Continuing, 'your admirable

Dallas's poetry doesn't look or sound the way we expect poems to nowadays. It employs predictable conventions: regular stanzas; unexciting rhymes and a lulling musicality (similes repetitions alliteration assonance abound); the subject matter is regional, prizing the 'elemental'; tone is unemphatic, almost credulous. Themes are the ground of forever: resilience in suffering, dignity facing tumult.

Yet by a curious turn in the logic of my own reading, I have come to see these as means to the poems' strengths. The best in Dallas is exactly this strange turning upon the limits of convention, prescriptiveness. Her allowing form to remain straight-forward presses us to search elsewhere: convention provides the framing device that permits an exploration of form-in-flux—a creative receptivity proves her most 'enduring' quality.

Dallas settles on non-assimilability, on a constantly defamiliarised residence. Take 'Autumn Garden':

> The trees she loved are loosening their
> leaves,
> But not for sorrow will they let them
> fall;
> Younger leaves are stirring in the bough.

bareness and simplicity of statement, one of the chief strengths of your work, does now and then just verge on the trite and prosaic' (12 Sep). Of 'River-Paddocks': 'very good. Have I said before that you create a whole world of your own, a world one believes in and can inhabit?' For the line 'This would be the first day' he suggests, '"This would be earth's first day" or better "might be". In this same stanza you have, to my ear, a great weight on the "a" sounds, possibly too much weight, which could be lessened by altering "banks of clay" to "clay banks". Next stanza, comma after soil would help; "old Egyptian tombs"— "old" is trite, isn't it? What about "once"?' (17 June 1951). The middle stanzas as offered:

> This would be the first day if long boughs,
> Like the hanging roots in caves the river
> scours
> In banks of clay, had left the air unchanged.
> Yet wind and light break up the willows'
> shade.
>
> Trees there were that hid the sun till root
> And fallen leaf and branch, the very soil
> Seemed stained for ever black with their
> deep shade,
> Old trees that guarded bird-song and the
> bones
> Of fallen trees as jealously as old
> Egyptian tombs their jewels and dead
> kings.

July's revisions (underlined):

> Now, when the world should pause,
> the bees behave
> As if these were the earliest flowers,
> beans
> Swell and swing on the trellis, apples
> ripen.
>
> Nothing in the garden looks for her,
> The summer flowers are scattering
> their seed,
> The heavy apples dream of other trees.

Here (often 'here' or 'now' mark a snapped-off present) is an autumnal poem that is not a dirge of passing. Instead of imminent partings, of decay, the bees are buzzing in anticipation. 'Sorrow' enables the speaker's 'love', though nature teaches or warrants neither. Letting go has not just to do with mourning; it is inbuilt in replenishment, resurgence ('Younger leaves'). Loss suggests 'the world should pause'; yet the bees will have none of it: they see and relish only abundance. That is why nothing in the garden 'looks for her'. She may look askance, out of desire, out of ignorance. That reveals only her own predilection. Other seeing requires opening to passing's company, the rotundness of 'heavy apples' arising not out of need or a nothing but out of an innate heedless fecundity. They are fully pregnant with it. And this the

This <u>might</u> be <u>earth's</u> first day if long <u>thin</u> boughs,
Like the hanging roots in caves the river <u>wears</u>
In <u>clay and stone</u>, had left the air unchanged.
Yet wind and light break up the willows' shade.

Trees there were that hid the sun till root
And fallen leaf and branch, the very soil,
Seemed strained for ever black with their deep shade,
Old trees that guarded bird-song and the bones
Of fallen trees as jealously as <u>once</u>
Egyptian tombs their jewels and dead kings.

★

The change from forest to farmland was so complete that it was not only difficult for later generations to imagine the features of the original landscape, but old people, when they returned to districts that they had known intimately in their youth, found themselves disorientated (CH, 110).

★

speaker's awareness must stumble into. Intentionality hollows out, is thwarted; it appears in reverse like a photographic negative.

'Grandmother and Child', 'River-Paddocks' and 'Boy on Rocks' reveal similar negations. In the first and last mentioned, the intimacy portrayed occurs almost despite the surroundings: the 'quiet old lady' is associated with the 'sea-sound' of trees, to wind in leaves, to a tide-immersed rock, to a 'large and cool' rock, again to a 'strong' rock. The final stanza answers to some extent the riddling comparisons. It is the child's credulity that reaches out for security amidst failing anchorages:

As the rock remains in the sea, deep down and strong,
The rock-like strength of the lady beneath the trees
Remains in the mind of the child, more real than death,
To challenge the child's strength in the hour of fear.

The twist is that in the grand-mother's rectitude the child, seeking comfort, finds herself summoned to let go of holds, beyond easy reassurance.

★

Attraction to an Eastern aesthetic starts at seventeen when Dallas wins a world anthology as a senior literary prize (*Southland Times*). 'I had read nothing of Charlotte Mew's except anthology pieces,' she later explains. 'They had the detachment that I admire so much in poetry, a kind of warmth through coldness—or perhaps coldness through warmth' (15 April 1953). Come October and still recuperating from an operation of the previous year, she writes that she is working on a new sequence ('The Turning Wheel'). This time she defends the reinclusion—resisted by Brasch—of stanza 3 in what becomes 'Headlands in Summer':

> Limpet-firm the root that tied
> Powder of seed in spray of storm,
> Holding the ripening flower from harm,
> Sweetening crevice and cliff-side.

She says: 'You asked, does it add anything? Yes, I think it adds, if nothing else, "ripening"—the grass-flower is not idly flowering, it is (in spite of its stormy position, and because it has been able to adjust itself to its environment) ripening' (19 March 1954).

★

'Letter to a Chinese Poet' is a tribute to Tang poet Po Chü-I and was a key contribution to New Zealand poetic thinking. Understated and disarming, it provides a counter-narrative to the 'South Island' and national mythmaking prevalent at the time:

> Water in the house as from a spring,
> Hot, if you wish, or cold, anything
> For the comfort of the flesh,
> In my country. Fragment
> Of new skin at the edge of the world's
> ulcer.
> <div align="right">—'4. Clouds on the Sea'</div>

Distance and time collapse, 'awayness' proves nearby and not foreign or offputting—a jolt to the insistence of Curnow *et al* that reality be *local and special*!

> I am reproached by the pine,
> And the dancing wheat-field,
> And you reproach me,
> Shackled with I and *mine*
> More heavily than you were.
> <div align="right">—'14. Ananda'[3]</div>

Attention fixes elsewhere. Not towards England and its empiric peregrinations; now an encounter with Asian Buddhism fills the mindscape. Local welcomes afar, just as the still new land had welcomed her forebears:

'Letter to a Chinese Poet' is sent in its entirety (17 sections) in 1956. Following an invitation to make a selection for publication, sections 1–7 appear with minimal revision the following March. Sections 8–17 undergo more extensive discussion and alteration. Some insight is gained into the poet's working method when we compare the manuscript version of '8. Autumn Wind' and the 1961 version in *The Turning Wheel* (with excisions marked):

> But [W]ords would not have come to
> write to you
> If I had not seen into your heart
> As into water,
> In a song you made in tenderness and
> pity
> And self-reproach [W]hen a slave-girl
> ran away[,]
> Water lying over stones,
> Transparent,
> As where you bathed at the [t]emple of
> Wu-Chên,
> Or here, by any mountain[-]side.
> With always before you the image
> [Meditating on the symbol] of the
> clear pool[,]
> How could your heart not become clear?

From the mid-1950s onward the poet develops a more conversational tone, though spare in sentiment and diction.

★

I write this at the year's end,
A century from my fathers' landing ...
Cloud lingers on the bare hills.
The chrysanthemums that blossomed in
 your garden
Bloom now in mine.
Tomorrow—who knows where?
 —'16. The Year's End'

Uncertainty permits reality, reality permits displacement: 'Abroad on a short journey / ... Travelling ... / a hard ball spinning / Indifferently through light and dark' ('17. Beating the Drum').

★

In her late volumes *Walking on the Snow* and *Steps of the Sun* Dallas again shifts ground. Interest returns to the per-plexities of the human situated in externalities: where is deep sense to be found if not anywhere? Two late poems that tellingly capture this perplexity are 'Silver' and 'Japonica in Rain', creating an oddly alien earthliness. There is a characteristic sparseness, pristine imagery, a terseness of form that undercuts simple residence in either an outside or an inside, instead inhabiting a pervious border between them. 'Silver' etches a pear tree, winter-bare:

> The pear-tree is frozen,
> Its antlers in velvet.
> Fear stiffens branches.

[Through] the old Chinese poets … I found I did not have to conform to anyone else's ideas about poetry; but simply to write as I wished to write, to trust my own perceptions and to take my imagery and symbolism from my immediate environment … In contrast to European thought, they saw themselves as occupying only one facet of the myriad-faceted natural world, not as central figures (CH, 121).

<p style="text-align:center">★</p>

It seemed natural to me to choose 'The Turning Wheel' as title for a sequence of seven poems I wrote in 1953, since I had passed through a difficult period in my life, troubled by illness and a further experience of near-blindness from a new cause, and by the illnesses and misfortunes of others (CH, 122).

<p style="text-align:center">★</p>

It seemed to me at the time and still seems to me that simply by being alive we are walking on a dangerous surface (re 'Walking on the Snow').

<p style="text-align:center">★</p>

In the ice of daybreak
It calls with the voice
Of a hollow-stemmed wine-glass.

Deprivation and plenitude, mere bipolarities:

Joy is
Pain is
In a two-sided pear-tree

In the end—is there an end?—ends don't meet or justify anything.

The monarch's head at once
With the coin's reverse,
All barriers down.

The same still cascade of surplus feeling occurs in 'Japonica in Rain':

Rain is falling and falling,
Water cascades from the eaves.
Clouds cover Mount Cargill.

The Japonica outside my window,
Where sometimes a grey warbler sings,
Is closed like a fair-booth in rain.

They are gone, the children's windmills,
Red and yellow, white and blue,
That twirled on thin sticks in the sun.

The Japonica sings when the bird sings;
Falls silent when the bird is silent.
Tears are shining on its leaves.

The repetition of 'falling' suggests sadness, steadied by the observation of what's outside the window: Mount Cargill. Despite the solidity, absence and emptiness prevail—the warbler

We seldom saw snow in Invercargill, but most winters in Dunedin brought a light snowfall and spring was made more evident by the abundance of plum and cherry blossom, peach, hawthorn and broom ... Southland's dark evergreen shelter-belts, plains and open windy skies were to be seen no more; dense coastal native bush remained only in memory; but that Southland's poetic landscape still haunted me is shown in this poem from 'Letter to a Chinese Poet' ['Reeds'], which I wrote while lying awake one night in Crown Street (CH, 126).

<center>★</center>

The return of the sun each day has always seemed to me, as to others, symbolic of a new beginning. I was now writing poems in which I was not so often finding my imagery in the outer world as the inner world, and in which I was trying to eliminate barriers in the mind and between the senses so that I could think with more freedom. The 'Jackinabox' sequence is an interior journey, a restatement of a theme that occurs throughout my work, the ups and downs of experience, recovery after loss, mastery over confusion, another sunrise after the dark of night ... I once owned a Jack-in-a-box toy, a clown who, no matter how often I imprisoned him in his

has disappeared and the tree closes in on itself 'like a fair-booth in rain'. The simile is unexpected, a promise of enjoyment deprived. All gone. Even the (remembered) children's windmills, in their 'twirling' colours, all gone (forlorn 'sun'): only ever there precariously ('thin sticks'). But the hollowness empties and fills: rain falls. The japonica (the earth, life, a shared reality) is tenuously present and what occurs is sound then silence then sound, ad infinitum. In the moment, if briefly, destitution settles: 'Tears are shining on its leaves.' A rare use of metaphor: elucidation unnecessary.

In like fashion, showing a composure that permits what is, another poem, 'Overcast', maps a similarly weathered melancholy:

> Long waves rise up in walls
> And topple, knowing all is hopeless;
> They will never overcome the shore,
> Where the pines lie wind-racked ...
>
> Hours pass, and the planet turns idly
> As a child's ball spinning on a wave.

Without companion, ruminative, alert, the speaker turns about her own depths. Expansive objects are embraced, endorsed: turbulence in the skies seas clouds ('clouded'). The heavy 'rise' and 'toppl[ing]' fall of waves is ordained, unstoppable, as

box, sprang up again at the first opportunity ... Like most people I had become more aware of the earth's position in space as knowledge of the universe expanded, with the curved horizon that is visible from so many of our New Zealand beaches never failing to remind me that we are travellers in space as well as in time (re 'Steps of the Sun', CH, 176–78).

against the shore they attack again and again—without avail. Whence the effort? Tatty pines onshore are 'wind-racked'—unduly set upon by the same wind that helps topple solid, massed 'walls' of waves.

The final image literally breath-takes. This poet of similes finds a superb simile that anchors a mental stage, reducing the entirety of what it means to exist in the 'idle' rotation of the planet. She pinches the reader into a dumb-faced acknowledgement, combining the innocence of the child's ball (recall: 'windmills ... twirling'), abandoned and 'spinning' as purposelessly, on the same mass of water. So tender, so dire: such—Dallas tells us—is our predicament.

Notes

1 'The unfunny comedy of inclusion and exclusion never stops. Canons, sanctioned or prolific, are medium-term machines of reproduction – syllabi with their reading requirements, anthologies with their poets ...': Bob Perelman, *Modernism the Morning After* (Tuscaloosa: University of Alabama Press, 2017), Loc 409.

2 See 'Three Case Studies' in my 'Landfall under Brasch: The humanizing journey' (PhD thesis: Auckland University, 1982); also Dallas, *Curved Horizon: An autobiography and Collected Poems* (Dunedin: OUP, 1991/1987).

3 'Ananda' was reinstated: 'Why did I remove it in the first place? I did not wish to give the impression that I had changed from Christianity to Buddhism, only to point a contrast ... that one should try to stand on one's own feet, instead of looking for comfort, and so gain strength so that one can be of use to others' (7 February 1960).

SARAH SHIRLEY

Section 11, New Zealand Mental Health Act

He came in bearded, broken, stinking,
stroking soft visions floating in the clinic air,
feet scratched and nettle-stung, his hair
threaded with leaf litter. His thinking
scrambled, his speech all nonsense mumbled
of the beings sent to find and kill us all
and only I can hold them back, can call
the gods back down to save us. He rambled
on and on as we slid our needles in
and swabbed through stubborn layers of dirt
to find a small creature inside, cowering
from his own brain, the angry hurt
that reality had abandoned him once again.
When he left, the clinic smelt of earth and rain.

ESSA MAY RANIPIRI

echidna gets a name change

at the age of nineteen she doesn't really feel like a mum
not ready to be all split open and building an army
between her navel and her scales
feels pōhara about where it comes from versus where she
came from
before she can save the money to make it official
one-hundred-and-fifty-fucking-dollars
she gets her friends to call her Hinenākahirua
she don't want to be white-washed by the classics no more
she is a daughter of te Ao Māori & proud!

her friends are cool with it
the Olympians are not
think about everyone who will struggle
with the syllables don't want to be
putting knots in people's tongues
guilt trip on a slipstream Kronos stuffing rocks in his gob

she gets self-conscious then
maybe she hasn't earned a Māori name
maybe she won't fit in with it anyways
a second-thought piled on second thoughts

WINZ cuts her payment when they find out
about her moonlighting at the meatworks
makes the decision for her
Echidna remains Echidna in name alone

ESSA MAY RANIPIRI

echidna thinks about the future

she's scratching her eczema where her tail meets her flesh the
heat's gotten to her sweat and raw-red and dry in a way it shouldn't
be in such humidity will everything be mostly desert or sea?
Tangaroa become all bloated veins thick with CO_2 will ExxonMobil
one of the Seven Sisters so sickeningly named own what is left before
taking any responsibility? she can see them all take off in Tesla spaceships
the rich haunting whetū Elon Musk shit-talking Rehua the money-
hoarding bitch getting hit a pasty white comet collapsing into the
atmosphere he tried his best to escape the damage is done they
already took all the knowledge they could and thoroughly distorted it
whenua for jet-fuel our people removed from a world of sound does she
want to bring children into a place like this

ANNA WOODS

The Neverbird

3.02am

You are wakened by the baby's cry—a caw like a morning crow. It slices into the soft part of your brain, the place you go when you are asleep. The room is black. You reach for your phone to check the time. The numbers glow like teeth.

Your husband's breath is slow and shallow. He does not stir. You wait a moment. The cry heightens. Outside, a night-bird calls. You heave the heavy duvet off your shoulder and reach for the nightstand. Your eyes are sandy; you push your eyelids open but they snap shut again.

Your fingers find the tall glass you left on the nightstand when you collapsed into bed, the wrong side of midnight. The liquid is warm and fumy, rich with ethanol. You keep reaching, plumbing the dust until you grasp the plastic frame of your glasses. You unfold them and push them up the bridge of your nose, where they pinch at the soft skin beneath your tear ducts. The darkness slots into focus.

There is a beat in the cry now; the flap of a wing. You prop yourself up and the bed sags. It is cold. The warmth of your body clings to the sheets. You take a deep breath. The cry stops for a moment and you pause, half-sprung, hoping to drop back into darkness. But the next cry echoes even louder in the silent night.

3.09am

You slide your feet across the carpet, searching for the slippers that have somehow disappeared in the scant hours since you kicked them off, slinking your feet into the sheepskin. It is indented to the shape of your sole. They are the only footwear you have worn these past months; you do not often leave the house. When you do, the air sucks in and out around you—a swooping wing.

You lift your sweater from the crumple of pillows on the floor and pull it

over your head. The fabric is soft and thin with use. You pause. Another cry, like a scream thrown to the wind.

The stairs are the hardest. Dragging your feet; hewn stone. You pad up to the top then stumble down the hall. Outside the door you wait. Little gasps of silence hold you in place. After a moment you push the door open and step inside.

Shhhh, you say, *shhh, little one.*

He stops for a moment at the sound of your voice. It is lighter up here; the moon seeps, witchy blue, through a crack in the blinds. Pieces of furniture rise like wraiths; the hooded towel hangs hooked on the door; the cot is an open maw.

You place your hand on his back, *shhh, little guy, shhhh.* He curls at your touch. The cries drop a decibel but still come thick and fast like incantations.

You pick him up and hold him against your chest. He is almost silenced. A low whimper escapes, the last atavistic sound before he is soothed. You sway with him in the dark, feeling like a rotted-out tree, your bones soft as green branches.

3.14am

You weren't sure about having children but your husband, a little older, pushed it. It was easier than you expected to fall pregnant: it happened the first month you tried. You had counted on it taking longer—six months, maybe a year. But it hurtled at you—the vomiting, the swelling belly, the painted room, the tiny clothes, the scans—his heartbeat a rapid tremor.

At night, when you couldn't sleep, you listened to the distant call of a bird, shrill and long, a shadow searching for its owner. During the day, at work, you spent hours searching for bird calls, trying to identify the high rasp. The baby books sat on your desk unopened.

Everyone told lies about the clear-spun moment you would hold him in your arms. After his birth, clotted with anesthetic, you had the vague sense that you'd got up one morning and put on the wrong life. He lay nuzzled at your neck, his face squashed into itself. A stranger, no part of you at all.

The shapes in the nursery sharpen as your eyes adjust. They become heavier, square off. During the day they are soft-edged, whites and pale grey, natural linens, soft woods. There is no softness now.

3.22am

Your sister-in-law suffered four miscarriages, one after another. The last, only a few weeks before your son was born. She had crippling morning sickness, was barely able to stand, until each time, at around six or seven weeks, she would wake clean and cured, her hope dying again and again.

It went on over a period of eighteen months. Each time her face pinched in on itself a little more. She is wound tight now, closed as a shell. Each time her hungry face hovers over your baby there is a coil of guilt and a feeling of something missing, some triumph you can't quite grasp. More than once in the opaque small hours you have thought of lifting the creased bundle of him and presenting it to her as a gift. Sometimes, in the blackness, it is the only thing that makes sense.

3.29am

The fevers started at about three months old, his skin touching flame, heat licking up the walls of the bedroom. When they spike, you inject sticky paracetamol into his mouth and it dribbles out of his slack lips. His body becomes slick with sweat, his hair grows matted and he wails.

The thermometer is shoved into his ear, more and more desperately, at twenty-minute intervals. Most often, this culminates in a harried drive to the twenty-four-hour clinic and an endless wait in the purgatory of the overlit foyer. A tired young doctor takes his temperature, administers more medicine, and you wait again. Until the fever recedes enough to take him home.

Tonight isn't a fever night. It is a night like the wing of a bird, like creased feathers. You are stuck in the paper-thin gaps.

3.36am

You started reading to him months ago. He is far too young to understand but it soothes him, and you enjoy the shape of words in your mouth—your oracular voice, poetic and round.

You are reading *Peter Pan*. You place your hand on the hard cover, which lies on the table next to you. You can't make out the royal blue in the shadows but you can feel the gold embossing, smooth depressions under your skin. One of your earliest memories is of your mother scooping you into her arms and

reading, straight on till morning. You wonder if he will remember this too.

In the story, Peter is alone on the rock, water sweeping up. The Neverbird pushes her nest towards him, swimming with great effort against the rising tide.

3.48am

You try to lie him down but the screaming starts again. You wonder what it would be like to squash his head between your thumbs, to hear the small skull splinter like creaking wood. You stiffen with self-disgust, but it is not the first time. There are knives that gleam in the murk. Rivers of blood in your dreams.

But you also worry that everything will hurt him. You draw his medicine wrong, an extra sticky millilitre, and have nightmares about kidney damage. You take him outside for a moment in the pooling sun and melanomas grow before your eyes.

The moon is rising now, the shadows sharpening. The Neverbird calls in the bush. How many times? You are too tired to count.

He is finally quiet. You sit with him in the rocker next to the crib, and think of the glass beside your bed. Could you inch downstairs, take a sip?

Your throat is beaded with crystal. Your mind is a spider's web.

3.57am

His hair is soft, the belly-fur of a rabbit. You stroke it, gripping him tight, but he does not rustle.

Your mother was surprised when you told her—*I didn't think you wanted children.* But you had never said that. When you have been single for a certain amount of time, and reach a certain age, people assume things.

You wonder why your mother didn't warn you of what was to come, but perhaps she didn't know. She often told the story of the night you had come home from the hospital. She sent your father to check on you in the morning, too afraid to go herself—it had been a full eight hours, and you, the five-day-old baby, were quiet as a grave. Alive, of course, black eyes wide, silent in your cot. Mouth open in surprise at the world.

There's a bottle in the dresser. You think about rising, then with a sudden stab of delight, remember the one stashed under the nappies. You reach for

it, curling your fingers around its neck. It sloshes with the sound of meadows and honey. You twist it open one-handed and bend your neck like a swan, trying not to wake him. The warm liquid rushes down your throat and wraps you in something better than joy: numbness. You screw the lid back on and tuck the bottle behind you.

Tomorrow, you think, as you do every night. Tomorrow I'll stop.

4.09am

It was gradual, the drinking. You drank heavily in your twenties—who didn't? But when you first fell pregnant (the whole thing was like falling, like losing your footing and sliding away) you stopped, easy as that.

It started with a bottle of Guinness—good for the milk, you were told. The viscous, yeasty liquid felt too much like medicine to be harmful. You don't know when it swung, but soon there was whisky on the night-stand, and why tip it out in the morning? Might as well snarl it back to begin the day.

You met your husband in a bar but that doesn't mean anything. It is a fiction reserved for grainy films—the drunk propping up the bar. You far prefer to drink in the dark, alone.

Your eyelids are closing, the bottle is hard on your hip, nearly empty. Your neck is tight but you can feel the night receding. The sun inches closer; nothing is as bad in daylight. Tomorrow, you think. Your eyes drop closed.

You count your blessings: the one in the dresser, the one in the oven, the one in the freezer behind the peas.

Tomorrow, you think again before your mind slides off. The bird calls in the secret hush of trees.

4.12am

Your husband doesn't know. Maybe he suspects. The closest you have come to telling anyone is the Plunket lady, who visited with receding frequency in the weeks after the baby was born.

You sat in the lounge. He lay on a patchwork quilt your mother had made. Pale blue and lemon rectangles laid diagonally like a parquet floor. After he had been weighed and measured, the black stub of his umbilical cord checked, the lady rocked back on her heels and peered up, glancing around the room as if seeing it for the first time.

She was a squat woman, with a too-dark bob curled under her chin. Her neck was too broad for the flimsy hairstyle and she looked like a tree stump. She carefully asked, *Is everything all right at home, dear?* Then added, *You feel safe?*

Oh yes, you answered without hesitation. *Everything is great.*

The Plunket lady nodded and started to pack her bag, folding the linen nappy into perfect triangles. *You know,* she said in a neutral voice, *sometimes it's not what we expect, having a baby. Sometimes we don't feel how we think we are supposed to …* Eyes on the nappy, fold and smooth, fold and smooth.

You opened your mouth to speak, something about that 'we' swept around you, unchinked something, but the Plunket lady was already snapping her bag shut. She stood, brushing her polyester pant legs, and you closed your mouth.

Next appointment is in three weeks, the Plunket lady said.

4.15am

You dream someone is pushing the hard nuzzle of a gun to your back, marching you away from your son, who is wailing. You must fight through the gauze. Your eyelids flutter open. He is awake and crying on your lap; the nose of the bottle is hard in your spine.

You pull it out, lift him up, holding him with one arm against your shoulder. It is like leaning on the sun. You go into the kitchen to draw some medicine, nudging the vein of the syringe into his pursed lips. He licks them after, eyes closed to the naked light.

You stare at the moon, high and distant. There is a colour in the sky that is almost violet—the colour of fear, you imagine.

The days are quite different from the nights. After that first drink you have a long dry period, punctuated by rising light and your son's drift in and out of consciousness. His night sleeps are bad, but by day he naps a lot. Short bursts usually, forty-five minutes long, and he can take five or six naps a day. Sometimes, if you are feeling especially optimistic, you push him in the wide-wheeled buggy, up the steep rise of Maungawhau, and gaze over the spreading city. More often he dozes off on the blue and lemon quilt, kicking his narrow legs until they grow slower and slower and stop. You sprawl on the couch, a little triangle of sunshine falling across your shoulder.

Everything seems easier in daylight. It isn't until late afternoon, when his

cries escalate, and the hours stretch out until his father comes home, that your hand grasps in the black oven, or the laundry basket, seeking the hard glass bottle.

5.06am

Your husband walks into the kitchen, rubbing his eyes. The baby is asleep in your arms. You are perched on a dining chair, not moving. Your left buttock is numb. He takes him from you without a word, and you walk back downstairs and wrap yourself in blankets. Your hand snakes out for the whisky glass. It sloshes merrily as you raise it. You hesitate, then open the window and pour it out. There is a shinnying sound as it hits the grass.

Then there is the beating of wings, air displaced. The shadow of a bird crosses your closed eyes. The Neverbird. In your mind you climb inside her nest, safe now from the rocking tide. Warm eggs press on your knees and thighs. You wish, like Peter, that you had a hat to place them in.

You think of the bottles hidden around the house and close your eyes.

In the distance the flapping of wings subsides.

MICHAEL HALL

Outside, 3 Years Old

My mother gathers
The wide white sheets
Into a strange pregnancy.
I am sitting
On the fragrant grass.
The concrete path
Leads to her
And back to the house.
Listen
To Newtonian space—
The squeaking clothesline,
The sun lowering.
This is the last time
I'd know where my mother was.
Since then she has been
Wedded to time.

Before I Was a Shepherd

I was a child before I was a shepherd, but still living in dreamy-boy time when I took up that age-old occupation in the backblocks of New Zealand. Here I spent my days on horseback, along with the team of sheepdogs that were my constant companions and helpers. At sunrise we mustered the scattered sheep that grazed the thousand-acre paddocks of steep hills and forbidding limestone bluffs. Once the flock was gathered into a set of pens behind the weathered shearing shed, we subjected each animal to several undignified procedures.

Before I took on this paid employment I had chores at home, and the annoying distraction of school, where I did well but did not thrive. Otherwise I was out on the wild west coast on my pony.

Sometimes I would lean forward and drape my arms down my pony's neck as we meandered along the beach. Beneath me I could see the dry black sand at the top of the beach change as we moved closer to the water, becoming purplish, with a crust that fragmented into shards as the pony's hooves broke through it. A few metres closer to the pounding breakers the sand turned hard and wet, glistening defiance at the murky waves of the outgoing tide that constantly tried to engulf it again.

This was the spot where I first knew it really was true that the world was round, because I could see it spinning.

Once I looked down on myself, as I swooped and screamed my raucous gossip to the other black-backed gulls massed in the grey sky. I thought, 'What a weird kid that is on the brown and white pony,' and I rode the wind in one more circle above his head.

CLAUDIA JARDINE

An excerpt from 'A Gift to Their Daughters'

A poetic essay on loom weights in Ancient Greece

Part 3: The Importance of Textile Manufacture for Making Connections
Textile manufacture was also necessary for the induction of new women into the *oikos*.

I think about all the queens on *Drag Race* who don't know how to sew.

In Xenophon's *Oeconomicus*, Ischomachus reports to Socrates that his fourteen-year-old wife 'knew no more than how, when given wool, to turn out a cloak'.

Prior to what is widely believed to have been the early age of marriage, a girl would probably not have been large or strong enough to work the loom.

The dread when one of my friends, at age eleven, announces to the group that she is going to lose her virginity when she is fourteen.

'But that's only three years away,' we say.

She reneges.

'Actually, fifteen.'

Ischomachus, acknowledging that his young bride is not as skilled in wool-working as she could be, nevertheless still encourages her to teach the maid how to spin, and thus 'to double her worth'. The teaching of textile manufacture, Xenophon suggests, was the responsibility of the manager of the *oikos*.

I drop out of my Year 7 knitting club because no one is paying attention to me.

A new bride was integrated into the *oikos* through working as part of the group and building relationships with other women by sharing in the domestic labour.

My dad is furious when I decide to take a textiles class in Year 10. My mother has a needle in her mouth during this conversation.

The skills learned and the textiles made were also by no means frivolous,

as a column of the Gortyn Code states that on leaving her marital home after a divorce, a woman was entitled to take half of what she had woven while married.

Is there a moment in which a man finds a loom weight on the floor, in some sunny corner, and wonders what he has lost?

Am I romanticising ancient Cretan divorce?

The involvement of young girls in wool-working groups therefore eased their induction into their bridal home, while also providing them with the means to maintain personal wealth, should they depart from it.

My mother teaches me how to cross-stitch. It takes all five seasons of *Breaking Bad* to complete the paternal family crest. A belt and a spur, *Cave adsum*. I don't think to ask about hers.

TOM WESTON

Lost Boat

Today, the boat is adjacent.
Last week, it lay to the south, beached, and
with a semblance of rope trailing.
Plainly, the boat is making a journey,
though it seems unlikely it will get much further
around the lagoon.
It's not discouraged, having got
about as close to open sea as it can.
There is something sheepish
about the angle at which it now reposes.
Caught in the act, that rakish tilt
is saying, it's not really me.
Enquiries, so far, have proved fruitless.
No one has stepped forward to seek its return.
Sheepish will turn to desperate,
mark my words.
How much of the known world goes missing.
And even more of the unknown.
One call has led to another.
Eventually someone phones from the last village.
Have you found my goat? he asks.

Be Still

i.
Slattern: a
hoar frost:
a rime
Cold seed bed
Rot and slime
batter and:
 clatter
Gnaw at the root
Burrow
Clot
Bide

ii.
Rodent is hiding behind her torn tuber
The ivy and rosemary are hanging,
pendulous and petulant
next to a teetering and purulent poppy bud.
Tiny roses blink and twinkle
through their thorned verdure, just
as rus ty leaves patinate moss, like
miniature mushrooms do. At last,
a large magnolia trills her sing:
meristem: glisten-hark
leaf: sap silver-dell
lichen:
orange peel.
.till.

The Orchid Lovers

My cousin was like a slow-blooming plant. The kind that showed its beauty once in a lifetime.

Her existence had assembled itself in peaks and troughs; at the high points she experienced the small privileges of being the wife of a senior island policeman and the silent pride of being the mother of two permanently employed sons who were married to respectable girls. At the low times, of which there were many, she was bored, lonely and aimless.

She had liaisons, often unsexual, to fill in the long hours her husband spent on duty; and after her sons made it clear to her they were building their own apartments to live with their wives independently, she adopted four stray dogs, each representing one of her four lost children. When her relationships ceased and dog after dog died, she found herself at a dead end.

One afternoon she stood in her empty house looking blankly out of the kitchen window into her garden. The last remaining chicken of the flock had wandered to the front of the house and was picking at the pot plant on the lower step. She ran out of the house and shooed the silly creature away but not before it had disturbed the soil and chipped at the petals of the simple white orchid given to her by a relative on her fiftieth birthday.

She smoothed each petal with her roughened fingers, trying to restore the flower to wholeness. After watering the orchid she put it on a window ledge in the sun. She went inside, sat on the couch in front of her 60-inch television and flipped channels. *Adam and Eve* would start in three minutes. Instantaneously a woman holding a pot plant with both hands and smiling brightly loomed at her. 'My backyard nursery business is an excellent income-generator,' the middle-aged woman, much like herself, was saying. Instinctively she pressed four fingers on the opposite palm, something she did when she could not decide whether she was more interested or more sceptical.

She jumped up from the couch. She had forgotten to buy the fish for dinner, and by this time of day there was little hope of there being any left. How could she have forgotten? It had been the same every week since they were married—fish curry on Wednesdays.

She collected the food money from an envelope crammed between jars of freshly ground turmeric and ginger in the kitchen cupboard and hastily left to go to the neighbourhood market.

An old man, bare-chested and cross-legged, sat on the concrete at the market entrance. The sun, now at its peak, shone brightly down on him and the walu that he was selling. She bought one whole fish and did not bother to haggle or fuss about its darkened edges.

As she exited the market she saw a mother and daughter by the side of the road. The young girl, bored, was zigzagging through punnets of seedlings. She remembered the woman on the television, her mirror-image, and bought two punnets with five seedlings each, one beetroot and one tomato. She hailed the open-windowed bus that had turned the corner with the grace of a water buffalo, climbed onto the first empty seat and slumped back, worrying that she had wasted money.

As soon as she arrived home she scaled and gutted the fish. After scooping out the ghostly eyes and throwing them in the bin, she wrapped the fish head in last week's newspaper to give to the neighbour's dogs. She cut the fish into imperfect rectangles and soaked them in yoghurt and cumin. As she had half an hour before she needed to start cooking, she took the seedlings and an old wooden spoon from the drawer and went into the neglected garden.

Ignoring a stunted tomato plant and a moth-eaten cabbage, she patiently dug ten holes in one discrete corner of the garden bed. Here, the soil was untroubled by the boots of impolite policemen, her husband's friends who, after enjoying a tanoa of kava, would trample over the dead garden to get to the gate and, somehow navigating pot holes and ditches, eventually find their way home to their disgruntled wives. She transplanted the seedlings into the newly dug holes and covered them as one would swaddle babies, gently but firmly.

Unlike the surface soil which was hot and dry, the soil lower down felt cool against her ungloved hands. She breathed more easily and digested the sights, sounds and smells of the island: the anxious mongoose rustling

through uncut grass to get to its burrow, a skink basking in the sun on a tree stump, and clusters of frangipani infusing the air with thoughtless desire.

The next Wednesday she bought two more punnets of seedlings. After that, she didn't wait for a week to pass. On Friday she went to the island's only nursery to buy some plant cuttings. She wrote down in a fifty-four cent spirobind pocket notebook all the plants she bought each time she was given the shopping money: potted ferns, orchids, hibiscus, papaya, chillies, eggplants and tomatoes. She bought herself a proper gardening fork from Peters Nursery. Then she dismantled the near-empty chicken coop and used the wood and wire to make posts and mesh for the new plants. Instead of giving the fish heads to her neighbour's dog, she crushed them to make fertiliser.

One afternoon the neighbour, who had returned from Australia after seven weeks and was disappointed to learn that her dog had not received his regular supply of fish heads, stopped by.

'Husband has decided he likes the fish heads too, eh?'

'Sorry. I've been using them for my garden.'

'Wow! You've been busy. Gorgeous flowers. Juicy-looking tomatoes.'

'Would you like some?'

The following afternoon the neighbour reappeared in a flutter of excitement. She had used the tomatoes in a salad that she had taken to the boss's house and his wife had loved them.

'She will pay! For a dozen tomatoes.'

My cousin's business grew through word of mouth among neighbours, friends and family. She kept half the money to buy new seedlings, plants and equipment, and the other half she gave to her husband to allay any misgivings he might have about her new hobby.

In the tropical climate everything bloomed beautifully. In six months' time she had a thriving garden.

Mr Singh, to the disgust of his co-workers, wore the same coat every day. It was brown, shabby and smelt of fish flakes. He was a short man with a pockmarked face and thinning hair. He had unusually large hands, a female associate whispered to the others, shuddering. His co-workers could not understand how such an unappealing man could be married to such a

sophisticated woman (though they had seen her only that one time she stopped by), and put it down to the Indian custom of arranged marriage.

Although his boss scoured Mr Singh's work performance regularly, hoping to discover a reason to fire him, the most he could accuse him of was poor hygiene. In truth, he had no stomach for dealing with such issues. He kept his distance by emailing, telephoning and sending memos through his subordinates and ensured that he was never in close proximity to Mr Singh. On the day of Mr Singh's performance review, his boss came down with a heavy cold in the island's eternal summer.

What none of his fellow employees or his boss knew was that Mr Singh was a skilled gardener. Digging and turning the earth with his much-loved garden fork, he imagined that all the tiny creatures were living productive lives (unlike himself and the other IT workers), churning the soil, preparing it for growing wonderful things.

His wife didn't share or even understand his passion for gardening and would often comment on his dirty fingernails at mealtimes, and complain about the smell of fertiliser when they were in bed.

Mr Singh grew a variety of vegetables and flowers in his garden. He had no need for children. He patted and petted the hard shells of his pumpkins, coaxed his cabbages to grow and praised the deep purples of his eggplants. He was, however, proudest of his orchids, which he grew separately in a greenhouse. These delicate beings required immense patience, understanding and money.

One weekend Mr Singh had run out of supplies. He put on a clean pair of pants and a shirt to go to Peters' Nursery to buy more plants, planters and pots, and to escape his wife who, once again, was nagging him about not washing his brown coat.

He noticed her hands first. Where his wife's were soft, manicured and painted, hers were like builders' hands—nails broken, skin pierced and he thought he could see a splinter in the palm of the left hand. Instead of being put off, Mr Singh was entranced. He thought there was nothing more beautiful than a pair of useful hands—hands that worked, that created something. Head bent, he watched the hands inspecting seedlings, cut plants, pots—testing for quality. He heard a small voice from below: 'Sir,

please move, you are in the way of the orchids'. Mr Singh jumped, turning the shade of his pumpkins.

By way of recovering his dignity he said, in a single breath: 'These flowers are fine but if you are looking for something a little different I have grown some rare orchids in my garden. Would you like to see them and perhaps take a cutting?' He was horrified at what had just come out of his mouth. But it was like that whenever he began talking about plants—some force took command of his common sense. What on earth would he do if she said yes? How would he explain it to his wife?

He looked at the rest of her for the first time as she stood up and unfurled herself like an exotic orchid. She wore no makeup, a patterned skirt down to her ankles and a blouse that was too big for her: modest garments. She was far too shy to accept such a brazen invitation. But she did accept, and thereafter, my cousin visited Mr Singh's garden every second week at the same time—on Wednesday afternoons at 3pm after she had been to the market to buy fish. At this time, Mr Singh's wife was absent for a regular beauty appointment.

Mr Singh and my cousin became each other's support system—trading plants, exchanging information, lending equipment and offering encouragement and praise. Together they functioned much like a well-tended garden. As a result, their individual nurseries gained in reputation.

Mr Singh's work colleagues talked to him a little more now that he had become a source of affordable floral arrangements for weddings and funerals. My cousin's daughters-in-law were so impressed that their mother-in-law's nursery was making real money that they began to visit her regularly in the hope of some future monetary reward.

Exactly a year later, at the height of their success, Mr Singh and my cousin were arrested for the murder of the owner of Peters' Nursery.

Mr Peters apparently visited Mr Singh's house on the Wednesday afternoon after Mrs Singh had left the house for her beauty appointment. She discovered Peters' body on her return. When she saw her husband in the greenhouse calmly labelling one of his orchids, Mrs Singh, her face mutated from 28 beauty appointments, let out a shriek. She ran back to the house and called the police.

The police came for Mr Singh, and subsequently my cousin was arrested in her own home. The blaring police siren swiftly attracted attention in the small suburb and before long everyone had flocked to watch—neighbours, people from streets further away and even stray dogs—as if she were the odorous titan arum flowering, its corpse-like whiff fascinating and reviling all who regarded it.

My cousin was marked by her ordinariness: in intelligence, looks, dress and speech. But that day when she smiled at me, her bright lips resembled the scarlet petals of an orchid as the police led her to the battered police car (much to the shame of both daughters-in-law who were visiting at the time). Every part of her face seemed to open up, expand and bloom. I had never seen Watika look as beautiful or so clearly represent her name, which means 'garden'.

Perhaps we had underestimated her. In the space of eighteen months my cousin had managed to create a successful nursery from ten seedlings; was she capable of murdering a man who had become a rival? 'This is an unfortunate case of still waters running deep,' the lawyer for the prosecution was quoted as saying in the *Garden Island*, the island's newspaper.

To this day I have not been able to figure out what lay behind my cousin's smile, except that it gave off an aura of satisfaction. As if she had achieved the extraordinary. Later, it was revealed that the police had found journals in Mr Singh's workshop on plant pathology and orchid biology with the following chapters bookmarked: 'The mysteries of orchid evolution' and 'Fantastic variations of orchids'. They also found Latin text scribbled on a piece of paper: *Dendrobium amaremortem*.

What had transpired among the three of them that led to the death of Mr Peters would never be known for certain. The defence and the prosecution put forward opposing theories.

The prosecution asserted that Mr Peters had been on the verge of exposing the twosome for creating a hybrid orchid so strange that it was an 'abomination'. A witness for the prosecution, Mr Peters' assistant, said: 'I overheard Mr Peters say on the telephone that he was going to see for himself what kind of Frankenstein they had created and put an end to it.'

The defence for its part argued that Mr Peters' death was purely accidental. He had tripped in Mr Singh's greenhouse, ironically on one of his own potted

plants, and fallen forwards onto a garden fork, as was indicated by the four holes in his chest. It was a tragedy, but not the result of any crime committed by his clients. And where, the defence asked, was the supposed offending plant, the very crux of the prosecution's contention?

In the end, Mr Singh and my cousin were found not guilty.

Mr Singh had not been about, so Mrs Wati, a regular customer, had simply taken the plant she had been promised from the greenhouse. She assumed hers was the one with the 'W' marked on a plant tag, sitting slightly apart from the others. As she left, she noticed the Peters' Nursery van parked nearby. That Mr Peters was a shrewd man. He never seemed to tire of hunting for business. His way, she supposed, of maintaining a stranglehold over the island's botanics.

In the comfort of her home she beamed at the new orchid by her side—this was surely Mr Singh's finest work. The orchid beamed back with its silky, muscle-like petals in black, its enlarged roots that had cracked the pot, and its four prong-like scarlet columns.

DAVID EGGLETON

Lifting the Island

Virtuous sunlight lifts the island to prayer.
The abyss is dizzyingly blue to dive into.
Surfers are carried on the backs of waves.
Hotels rear balcony totems notched skyward.
Heat yawns with a reptile's tranced shimmer.
Dazzled clouds somersault; then roll away
from a day flapping in an ocean breeze.

Girls in just bikinis and flip-flops,
their long hair streaming in the wind,
weave mopeds and boards towards the beach,
listening to iTunes, white buds in their ears,
flat out in heavy traffic, as fat men
on fatter hogs roar along with the racket
of low-flying, propeller-driven fighter planes.

The beachcomber who once sailed seven seas
goes from bin to bin with freestyle hands,
grave as a mandarin in abstract thought.
Ripe stink of garbage; hot weeks of August.
He wears nothing but faded and ripped shorts,
his muscles ripple under sun-blackened skin,
his fingers toil to free mashed drink cans.

The old gods are curios, remade in the bar
as the grinning wooden handles of beer taps.
Those at the bar, heads bowed, dream of surf,
dream of white foam swept into a cold glass.
Fleeting moments woven like flower garlands,

a seaweed hula undulating in a ship's wake.
The howl of air-con strains to cool down rooms.

Catch the smoking wave on winged heels,
orchidaceous comber that lifts rose-gold,
before deep green, light green, greener, bluer,
deeper, darker, roller-slider rising, standing,
before weight of water beneath the standing
wave topples to wipe out, because the sea
has been stopped by land shelving beneath.

CATHERINE TRUNDLE

The Caravan Behind the Plum Tree

Above us skylight
digests the dawn, a bald sun
sunk through the kibbled husk
of bees, the mummied skin
of tawa seeds while

beneath the perspex plate
we are sinking
into bone, cavity, glands.
By this hour we're all
hard favour—no appetite,
all muscle and whistle and rust.

This lush cusp of spring rides
pinkish, amoebic, wilding
the inside, every flesh 'n' cranny
while the sunlight lungs in
through winter tidelines
of curtain rot

Ghosts

Note: Contains violence

Show's nearly over. Dusk brings out the ghosts. Final act. Grey heels in the thick-bladed grass. Asaro Mud Men. Earlier: pink, red, yellow shake and sway. Grass skirts, Trobriand Islanders—Pam's favourites.

But now it's the Mud Men. Naked bodies painted in river clay. Masked. Eyeholes dark, nostrils curved. Armed and hunting. All for show—thick-tipped arrows resting, bow strings slack. Spooky now. Terrifying in the pitch dark. But there's a 10pm curfew. Cops cracking down on the raskol gangs.

My place, Port Moresby, Moitaka, the '87 show. I'm above it all. In the small announcers' booth, looking down on the circle of grass. Kila, new girl, next to me. Crowd's dark, freckled with pale faces. Red buai spit splatters dusty paths. Looks like blood.

Fence keeps the dancers from the rest of the show. Don't know why—easy to climb. Inside: a sing-sing. Groups from around the country, dancing, singing, drumming, weapons for demonstration only. Several at the same time, though now it's just the Mud Men. Bloody good show.

Over the fence: a fair—stalls and ads. Rice, sausage rolls, softdrinks, candyfloss, visors and pinwheels. Banners for Haus Bilas, Steamships, Coca-Cola, Fuji, Burns Philp, Benson & Hedges.

'G'day.' The word's at the back of my mouth. Spit its growl into the mic like it's the buai down there. Pam would have ticked me off. 'Too ocker.'

Got to be from somewhere, here. Inside the fence, before this last act, dancers in each group held signs: 'Porgera, Enga Provence', 'Angoram, East Sepik', 'Kundiawa, Simbu Provence'.

She was from somewhere too. Back there now. Twenty-six years after 'I do'. Go pinis tru. Stepped onto a plane at Jacksons. Left the raskols, rainy season Christmas, me—all her complaints. Back in her native land now. Sheffield, Yorkshire. Green rolling hills, I've heard.

'G'day Moresby.' Been saying this stuff since my first show in '81. Rolls

out, almost says itself. 'Thanks to all today's performers and sponsors. On your way out take a look at the Rice Industries stall—grab yourself a kilo of rice for a reasonable price! Behind the Mitsubishi tractors.'

'Terry?' Kila's hand could be on my shoulder shaking—it's not.

She takes the mic, fingers dancing at the on button. Says something close to it all over again in Tok Pisin. Doesn't mention the rice.

Kila: vowels immaculate—like the rest of her. Dress white, hibiscus red and orange exploding across it. Not one crease. Me: sweat-stuck to the swivel chair, eye to Kila's chest. Unavoidable, she's standing. Used to be Imbi up here doing the Tok Pisin. Easier with a man. He's gone. Everyone goes. Over to EMTV—doesn't do amateur gigs any more.

The ghosts are off. Grin of pigs' teeth in wide clay gums catches me. Each tooth gruesome. Have to remember that under the mask is just a bloke. His feet are meat and blood and tendon. Like anyone's they'll make the touch-me-not grass down there fold and shrink. Not a Papuan plant. South American—grows like it owns the place.

'Just men.' I've said it out loud. Kila can't stop her eye-whites telling me what she thinks. Might as well twist a finger at her ear. Long-long, waitman. Old too.

'Of course,' she says. 'I'm sure you know the legend.'

Wait. This way she'll have to tell it.

She sighs. 'A long time ago the people of this village—it's near Goroka.'

Nod, look wise. Transforms me into a better sort of old man.

'There was a battle. The warriors of this village were losing badly, so they turned and ran. They jumped into the Asaro River and hid. When they came out, the river had covered them in white clay. They looked like ghosts. Their enemies from the other village were so frightened by their appearance that this time they were the ones who ran.' She pauses. 'So the story goes.'

'And?' I'm after something.

Kila's hand's in her hair, tugging at its close-cropped froth. Could be Pam, irritated as sin. Uncanny. Jolts me like one of those thick-headed arrows down there, shot from close range.

'And ... as you see ...' Her finger points at me, then flicks. Single-fingered slap. Lands on the near-empty fenced area. '... it became the tradition of the people of this village to make these masks out of the river mud and to cover

their bodies in it too, before raiding a neighbouring village.'

Wiggle my eyebrows, ready with an observation. One I save for this conversation.

'Performing here gives the game away.' I've said this before. Said it to Imbi last year. Stretched his white teeth into a grin. Clapped me on the back. Or shoulder—not so sweat-stuck.

Ticking sound: Kila's tongue on the roof of her mouth. Pale echo of Imbi's back clap. 'You like it, don't you, you expats? Something you've never seen before. Such a good show.'

How to take this? Course I've seen them before. Been here ten years! Born and raised in Perth, but Moresby … this place bilong mi. A man can live well here. I've worked hard. Don't know Terry Connor? You haven't been in town long.

Hand on my wrist now. Kila's. Surprising. Hairs on my arm stand. Maybe not such an old man after all.

'Terry,' she says, 'I know as much as you about the traditions of this village. It's not where I'm from. My mother's village is in Milne Bay. You know, on the coast, not the highlands.'

Been to Milne Bay a few times. Would tell her about it. Interesting traditions. Something—maybe the thought of Pam's face, puckered lips, dog's arse—stops me. Tired anyway. Been up here since eight. Making small talk with the crowd since midday.

Kila's looking at her watch. Man's Seiko digital, stainless steel band. Done something to fit it to her skinny wrist.

'Need a lift?' I ask, thinking of the arm pat.

'No,' she says. 'Do you?'

Think she's trying to be funny.

She says, 'You can't drive alone. You'll be a target for raskols.'

Raskols—men who've come away from their villages, looking for opportunity in the big city. Instead they find disappointment, poverty, violence. Join a gang—what else is there? Family's hopes weigh on a man. Not that I sympathise. Theft's one thing. The brutal stuff? Read about it in the *Post Courier*. Daily. Rape, murder. Sick. Though none of that's ever happened to me. Dangerous city? Not if you're careful. Not if you know what you're doing.

Kila's giving me a once-over. Makes me fold my arms over my belly. Bigger than it used to be. Lager-grown. Splutter of anger there now. 'What do you take me for? Of course I know not to drive alone. Going in convoy with the others.'

'Others?'

'Lions.' Club's how I got this gig in the first place.

Behind us: footsteps. Man's head appears around the makeshift door. Strolls into the sound booth. Brown, well dressed—white shirt, short sleeves, trousers. Takes Kila's hand, cross of fingers like he's weaving them together into a string bilum. Gold on Kila's ring finger. Didn't see it before.

They're talking. Not Tok Pisin. So I don't understand.

Pam used to drive from Moitaka back to Boroko after the show. New freckles on her arms at the wheel each year. Silence between us in the old Land Cruiser last time. Seems a thin terror now. Worse being alone.

Home, half an hour before curfew. Dark's long settled. Rain tree in the garden drips leaves, tapping at the wire across the glass louvres. Tree darkens the place. Cools it too. My place: government-owned, weatherboard, grey paint, lick of yellow around the windows, raised on stilts—stops the snakes slithering in. Inside the door, deadbolts: one, two, three.

At the fridge, grab a VB and a second. Cold cans sweating. Do the thing (one of them) Pam hates. 'Uncouth'. Roll one can across my forehead. Then over the back of my neck. Now onto my belly. Chill makes my stomach suck and tuck, hides in my ribcage. Walk back into the living room towards the front door. Belly's no longer the first part of me over the threshold.

Pull the deadbolts back. Call out to George.

On the wooden deck, two chairs, George, me. Sipping beer, crowded by bougainvillea. Green leaves, pink, paper buds—all blue in the dark. Nest of red ants inside. Big, nut-coloured, weavers. You can see their black eye dots. Never seen an ant's eye before Moresby. Pam cut the bougainvillea, whacked it right back two days before she left. Heard a screech, thud of secateurs. She ran inside, past me straight to the shower, slapping ants from her arms. Looked like her freckles falling off. Day she left, it was contained. Only growing on the front railing. Now it's all the way around the sides again. Nearly at the yellow front door.

Storyteller, is old George. Belly even bigger than mine. His village is somewhere near Mount Hagen. Legs as wide at the calves as they are at the thigh—almost. Hands pale at the palms, dark on the tops. Tells me, when he first came down to Moresby, some waitman called him Jack because he could lift a car with one arm. Old story. Good to hear it tonight. Everything different, nothing changed.

Pinch my thumb and forefinger together. Ask, 'Liklik kar tasol?' Know the answer, of course.

Shakes his head. 'Bikpela kar.' His arms wide, like it's a story about a fish.

'Tru?'

'Tru!'

I reach out, slap his shoulder. Stings the meat of my palm where the lines curve across up to my fingers. George's skin is wet too. Not the way mine is, like I've just been swimming.

He lifts his own hand. Uses it to crush his VB. Transforms it. Just two aluminium circles on top of each other now. Waves to me for my empty.

'Lukim yu.' The steps shake as he walks away. Deck to ground. Gone. To the bin, then back to his place.

George's place: behind mine, part of the property. Tin roof, concrete floor, two rooms. Only him there tonight. Other times a few of his wantoks too, sleeping outside on an old wood platform, securing the place. Call it a boy haus but he's no hausboi. Too old. Sweeps the tiles every now and then. I've got no real work for one anyway.

Neither of us are what we once were.

Midnight. Awake. Limbs spewing from the bed sheet. Eyelids stuck with salt and sweat. Bladder full, swollen to burst with the beer. Prostate on the blink. Rip the sheet from the bed, tie it around me, into a lap-lap. Tuck it in high, under my armpits. Covers my chest, gut, dick. No one to see. Still.

In the bathroom, hand steady on the wall, head aching, bladder emptied. Washed up. Sitting, bath edge cool beneath me, beneath the sheet. One eye on the lino floor, the other on the past. They creep up in the night, old things.

'I don't want to leave you,' she said, 'but I won't stay here.'

Same thing.

Back to bed. Moth in the room. Brown, Hercules. Bashes the black spots on its wings against the window. Louvres are open but mesh blocks its path. So desperate to get to the moon it keeps going. Thump, bump. Thump, bump. Rhythm to it. My edges loosen. Blur into sleep.

Thump, smack. The moth? Crack. No. Sitting now. Feet cool on the red New Guinea rosewood. Groggy. Slow to come back into my own head.

Shouts, another smack and another. A ripped half-scream. Turn my head, left, right. Trying to shake the sleep out. Neck stiff.

Something hammers the door. There's a cracking snap. I know this noise. Made it myself splitting wood on a stump. Can't see from the bedroom but know it's a bush knife, slicing the front door.

Men, raskols, three of them, arrive. Two bush knives, one spear. Two bare torsos, two black balaclavas, four arms thick with shining muscle. The last man: T-shirted, slender, no mask—a kid. Teeth and eyes so white the moth, dead on the floor, would fly to him.

I'm still on the side of the bed. Dim like the light.

'Kisim mani,' says the man with the spear.

'I have.' Fright makes me babble. Try again. 'Mi kisim mani.' Belt of money under the bed.

Spear's on me, pressing my belly. Sinks slightly, doesn't cut. Barbs down its tip. If this man wants, he'll rip me open. Below the spear, my guts grind and squeeze, wringing out sleep and grog.

I raise one hand, palm open. Put the other to the spear tip, so it won't tear. Turn and bend to the floor. Rush of air stings my face. The kid. He's stepped forward, slashed the air next to me with his knife.

Keep going—the money's under the bed. The man with the spear twists his arm. Punching thrust, drag and rip. And pain. Drives into me. Into my palm, like a dog bite. Force of it pushes me over. Chin knocks the New Guinea rosewood. Teeth throb.

Spear's in the heel of my right hand. Tip's through. No blood. Just the barbed stick pushed deep into the flesh of my palm. And a pulsing, searing pain. The man on the other end has let go.

'Under the bed! Aninit bet.' Voice shrill, head wobbling. Push back up to kneel using my good hand. Legs sick, sicker than my spear-stuck fist. Fear filling my thighs. Rocking, rolling nausea.

The men speak. I'm lost. Can't even follow the movement of their chins, hands, eyes. Kila speaking with her husband again. Seems years ago.

So it's not enough, Tok Pisin. Waitman's language. Useful in a place of valleys and mountains and difference. That's all.

The man (his spear in me) gets down on the floor. Next to me. So close I smell the necklace of sweat at his balaclava. Salty musk. Slides his eyes across me—bound in my sheet, struck by his spear. Puts his right hand under the bed. Stares from the holes of his balaclava. Into me. Pats the floor. Nods. Pulls out the belt. Stands. Unzips it. Nods again.

'Sanap.' He motions to me to get up.

Hand throbbing, legs shaking. My foot trips, catching the sheet around my waist. Feel it slither, body to floor. White stomach, pink nipples, purple dick. All of me unwrapped, on show.

'Guh-ha.' The kid makes a noise. Claps a hand to catch it at his mouth. A laugh. And another. He can't control it. Guffawing like he's never seen anything so funny. Points at me. Me: naked, spear-stuck, crazy, old, white man.

Dragging ache—different to the spear. Pinches at my eyes and throat.

Other two catch the joke. Point and laugh. They turn, all three. Stumble from the room and run, through the slashed mangle of front door and into the street.

I'm after them. Legs tripping, dick wagging. Down the hall, into the living room. Hand high so the spear doesn't hit anything—chairs, walls—make it worse. On the deck, look out under the rain tree at the street. Gone. No one. Nothing. Punch of sick in my belly. Climbs my throat. Out it comes: beer, rice, coconut chicken onto the bougainvillea. Breathe—gulp wet air through stinging nostrils.

Something's here. Feel it against my bare foot. Top of the stairs. Warm, wet tack. Crouching now. Squinting. Solid calves, splayed and spread. George. George, face up to the purpling sky. Third bush knife slit into his chest, handle sticking out.

View of the Jacksons' tarmac, red hills, patchy scrub. Window seat. Flight attendant fussing over me, my bandaged hand. Gives me a straw, small box of juice. Plane lurches, wheels lift, pressure builds in my ears. Something else

too. What? Hard to say. Turn back to the window. Flat terminal getting smaller. Eyes see it but not me. I'm seeing: hands, pink on the inside; a flattened VB can; a car lifted into the air, easy as a baby. No way out, not for him. Good hand shakes lifting juice to my mouth. Slurp of it sprays from the straw onto my shirt. Drink. Cool, sweet on my tightening throat.

KERRIN P. SHARPE

Trial

the twins are eleven days old
when the researchers
from Health and Safety arrive

tall labelled chest of drawers
hats singlets nightgowns
muslin squares stretch-n-grow √

swept floors clean benches oven √

the researchers glide towards the laundry

one changing table
with thick plastic pad
and prancing bambi √

white spirits for umbilical stumps
kiddy lock?

the driven snow of sixty cloth nappies √

nappy buckets!

hungry bacteria and soiled
nappies crouch in two buckets
on the floor
of a *curtained* cupboard **X**

the researchers/soothsayers
wash their hands for the trial

the twins will soon arch
their bony spines soon stand
on their tiny hooves

soon follow each other
like water diviners

part cupboard curtains
haul out the nappies
with more strength
than women at the well

PETER BLAND

America

Corned beef hash
and burnt black coffee
at The Marilyn Monroe Deli
outside Palm City
with a desert wind blowing
through tight plastic blinds
and a hard light
that zig-zags
Marilyn's nude body. She's
a cardboard cut-out
stained with syrup
and gravy. O America
for all your flag-waving
and that gun on your hip
I can't help recalling
your wartime GIs
with their jeeps
and their smiles
and those candy-coloured cars
that surfed through the 50s
with Marilyn on the back seat
seeking her lost Daddy
and Walt or Hart Crane
thumbing a lift
like sex-starved college kids
in love with everything. Driving
west the air's like wine. You
can dine on it. It
opens up huge geographies

of the heart. As
I pay my bill
the sun drops down
behind Boot Hill
like a shot coyote. Marilyn
purses fiery lips
and everywhere
there's that raw sweet ache
that comes with the loneliness
of all late-comers
and their sense of being
forever unfulfilled.

K Road

Everything closes in this city
except for Karangahape Road.
I've never been awake long enough
to see the dawn come up over
The Mermaid Club and catch a glimpse
of the women slipping home.
I imagine their tails are tucked
into their coats; imagine they brush
mascara cheeks with the corner girls
and the coffee shop gives them
an extra shot for free. The sun sweeps
through here but it doesn't pick up
the cigarettes from last night, just
burns melanoma into our skin.
German backpackers trudge up
to the cheap hostels, their whole lives
nesting on their backs, tucking maps
of the big smoke in a tiny country
into their pockets. Everyone leaves
eventually. Houses cost a million
dollars here. Median price. But
K Road is holding on by her fingernails,
still goth but can scrub up when her parents
have friends over for tea. She is tucked
between Queen Street and Ponsonby
but everyone likes slumming it
sometimes, likes vomiting their night
somewhere, wants the nobodies
to have a place to be nothing so

they've left us this strip of gas
stations and noodle spots, strip
clubs, pubs, an Asian veg shop
and what's left of St Kevin's
Arcade. The lights are always awake
here, where the clubbers stand
in the middle of the road and taxis
swerve and pizza is sold by the slice.
We pray in different tongues but
we all worship the same concrete
god. Spraypaint on our fingers
and smoke in our hair. These
children of the Sky Tower; too poor
to afford a mirror so we just write
poems and hold a lighter
in the air.

RIA MASAE

Jack Didn't Build Here

This is the house that Dad built.
Foundation laid with stories
from sitting under the ulu tree
to learnings from palagi scholarship:
for wife, for offspring, for aiga.
Sunday School teachings echo in his mother-tongue
dotted with Oxford Dictionary words.

This is the house that Lange built.
Southside prime minister. The only home
in the hood with a pool. He invited the locals
—his Mangere locals—over to swim
and understood the pressures of fa`alavelave,
cos he brown on the inside like that.

This is the house that Mum built.
Chandelier hangs over the heads of churchy
poker players, cheating and laughing on
the woven fala. Celebration trestle tables
laden with islands of sapasui, oka,
fa`alifu talo, palusami and umu pork
surrounding a pavlova cheesecake.

This is the house that Key built.
Double-glazed windows within a security code gate.
His pool stretches across his Parnell palace
where riff raff are never invited to take a dip,
instead he swims regular laps to drown the reality
of midnight figures huddled inside torn sleeping bags
outside glaring high-fashion mannequin stores.

This is the house that I built.
Born in brown central, raised in gentrified central,
now in state house central. Wallpaper designed with parents' language
smudged into Samoglish. One post carved from
the ancient va`a of bloodline ocean wayfinders.
Other post a mighty kauri etched with Hans fairytales
and Chinese script I feel for but can't translate.

What house will Jacinda build?
Will it enable my daughters to build their own homes
of tangata whenua foundations and fa`a Samoa roofs
in this palagified City of Sales?

TAM VOSPER

Ailurophilia

for Artaud, my cat

Your chatoyant eye
filched the lizard's,
snake your spine,
your undulant tail:
piscine. Bear-pawed,
you lope from the kill
with bobbing scapulae
epitomising nonchalance.

All Gallic pluck
and casual loft
you claim a suntrap,
slump sidewise down,
and unhinge your barbed yawn:
 a shark to shoaling mice.

ZOË MEAGER

Spike

She has this little black button at her fingers and she presses it and goes where she needs to for a minute. Her body is like the frozen cannelloni that her mother dredged from the deep chest freezer that year they were snowed in and the power went out before they could get it cooked. Canned pears and condensed milk that made miniature snowscapes in her pudding bowl. But her body will not defrost, although now she imagines herself over there, just over there, off the bed, three steps away and onto the concrete porch that the curtains are half hiding shyly. The chair in that wedge of sun that the day has portioned this room, she imagines herself over there, her bones and her skin thawing. An old dropped chop on the kitchen floor, a popsicle that's skidded down to the footpath. The drizzly pool of her being lapped up by a dog. A great dog. It is going in slow motion, this dying. Dancing with her father, slow slow quick-quick slow. She is tiny, tiny things are enormous to her: a loop of carpet, the plastic mermaid from the edge of a cocktail glass, a paper-wrapped matchbox of secrets. She is enormous, her body under this sheet is made of pieces of pear, *James and the Giant Peach*, she is white and wide like hills like white elephants, she is the beginning middle and end. It is quick, this dying, an insect flitting unnoticed past an ogre. *Notice this.* She is clinging on to upright, sheets scrunched in her fists, heaving spoonfuls of air and balancing, balancing, the mattress digging into her sit bones and her foot is in the sun and she is up, rolling Spike beside her, *come on boy*, she is upright, holding him while he drips, she is stepping, her legs are unreliable narrators, stepping sideways now, now forwards, forwards quick-quick slow. *I can't keep up with myself.* The door handle, moving mountains, Muhammad Ali. In the chair in the sun there's a bird on the lawn, or a brown smudge, or it's only her eyelid bringing her inner world back down again, and the blades of grass are all painted green and who has sprinkled all that glitter on the lawn?

ERIK KENNEDY

All Holidays Are Made-Up Holidays

I don't think we were ever happier
than on Cabinet Day, when we went along
from house to house hanging little doors
around each other's necks to hide our secrets.
It was the perfect winter holiday of childhood,
when malfeasance and desire both
were masked by smells of baking cakes, of fennel,
aniseed and cloves.
 On the other hand,
we only understood the Feast of the Holy Indifference
when we were older. Some years it was in May,
some in June. The fête would last as long
as one candle burned. The Indifference Queen
or King, if there was one, soothed us with a dance
danced sitting down, in silence. This was how
we learned a single-minded lassitude.
 Which brings us to
the pagan rites of Multifunctionalia.
This holiday, they say, replaced still other
older, darker festivals, all hoof and genitals
and welts and berries! In our time it was still
an orgy of party-hopping, wrapping beds
in coloured plastic, shouting jokes we'd written
out of passing cars. There was so much
to do. It filled the summer like a dirty job,
just like it was supposed to.

Kalaupapa Love Note, 1923

Honey Girl,

Meet me by da slaughtahhouse, you know, down by da path lead to switchback twenny-six. Me? I hide in da `ohelo-kai bush neah da lighthouse afta sandwich lunch at Baldwin House, den walk da lava to yoah side. I be waitin' undah dat beeg ironwood wheah we wen first kiss. Pray dat *momona* butchah no turn on da grindah or shreddah. I no like heah dose puah animals cry.

Funny ting is, dey like fo' slaughtah us lil bit atta time, frown wen we speak Hawaiian an' take away dat Hawaiian Bible *tutu* wen geev me. Planny *pilikia* fo' keep lepahs alive. Gotta build church, house, hospital, movie palace, all dat kine stuff. Gotta barge in cow, pig, sheep, toilet papah, medicines, soap, bandage, even bag rice an' case Spam. 'Spensive, no? Bruddah Dutton no like drop line Kalawao side. Dat deep blue stay *ulua* waddah an' Dutton can hook 'nough fish fo' feed all da keikis an' old timahs one week easy. Sistah Benedicta make planny soup boilin' heads. I like try fish. Me an' Keoni an' Bernard drop *kaka* lines in da rough waddah by da rock shelf. But *auwe*. No can. How come Faddah Dornbush no like us lepah boys fo' help out? Can. Us boyz get *mana*.

We go walk Awahua Beach, da black sand one. Try come wen da sun almos' *pau*. No say no. Easy for sneak out Bishop Home—no get nun watch or dat *boto* guard who like sleep you. Remembah, no be chickin.

<div align="right">

xox

Okole Boy

</div>

Notes

auwe: my goodness, damn
boto: penis
kaka: cord with hook but no pole
keikis: children
mana: spiritual power capable of
 enhancing physical strength

momona: fat
`ohelo-kai: a succulent-like shrub with
 red berries
pau: done, finished
pilikia: trouble
tutu: grandmother
ulua: skipjack

Workshop

It's a Saturday morning and you're doing the usual stuff you do on a Saturday
 morning
except after that you'll do something you don't always do on a Saturday
 morning
and go into a room where people you don't know will come
in order to do something you know a little bit about
but not as much as you would like to
so for the morning you're going to pretend you know a lot more
because they're coming to listen to you and do what you're telling them
but before you tell them what to do you're going to show them some things
that other people have done
with the hope that this will help them do the thing that they've come to do
but when the people start to arrive you realise that many of these unknown
 people
come to these Saturday morning things in the hope that you will give them
 the secret
that will make doing the thing they've come to do easier and will lead to great
 success
like this one man whose name is something like Robert
a name that can easily be shortened
who will introduce himself as the shortened version
and say something about already having the secret
but that he has come to this Saturday morning thing anyway
and so when you've told everyone to do the thing they've come to do
then Bob only does that thing for one or two minutes
and after that he sits and stares at the table
while everyone else has their heads down doing the thing they've come to do
and when you look up to see if Bob is okay
he starts to stare at you as if to say do you want me to tell you the secret

and then comes to show you the thing that he has done in one or two minutes
the thing with the secret in it
and you realise that while some people here are adults
well some of them are still kind of children
and you're not saying you have the secret but sometimes it feels like maybe
 some people
 wouldn't know what to do with the secret even if you had it to give

CILLA MCQUEEN

Poem for my Tokotoko

Drawn from a basket-dam weft at the river mouth
out of storm-wrack swept down to the shore
from the Longwoods into Te Waewae,
Orepuki hopupu honengenenge matangirau,
I dare to think, my tokotoko,
that you're a wand of Celtic wood, the gorse.
Your root, a bird's head, tapers to a copper beak,
below the copper greave a sky-blue ferrule
touches earth, your silk-skinned
riverine sinews parted and entwined
as if it were my life flowing towards the sea,
inflected by wounds, irregularities, bumps, holes,
where sap has eddied in response to change.
Set on your neck a curl of orange metal;
attached to this, a supple fall of satin ribbons
imprinted with my own vocabulary.
Sometimes I see you as an enchanter's staff,
scattering poems like leaves to the west wind;
at others you're practical, a trusty pole
by means of which, through quarrelling
undercurrents, I can ford turbulent water.
By means of which I put myself across.

JOHN ADAMS

Narcissus

Reading is like coming to a mirror,
knowing not what face your gaze will return.
Like a bulb attracted by the spring sun
our youth extends his legendary face,
leaning beyond the pool's brink from which,
his narcotic echo floating up, he drinks,
of that changeling potion, his portion.
Readied ever to glaze some recognition
dredged from distorted depths, things
that pressure has brought to bear, this surface
refracts a maze wherein we suffer, by insight
blind, total floral alteration.

JOY HOLLEY

The Sisterhood of the Travelling Nit

When my friends and I were teenagers we gave each other nits. More specifically, one friend gave the rest of us nits. She always smelled of tea tree oil. One night I plaited her hair into a hundred tiny braids because she asked me to. I would have done almost anything she asked. We slept with our faces pressed together.

I was halfway through the listening section of a French exam when I found my first nit. I was so horrified I missed a whole passage. That was the lowest grade I ever received. Another friend told me later that she also found her first nit during the listening section of the French exam, though she might have made that up. She had very curly hair, and sometimes when people saw her from behind they mistook her for Lorde. At least that's what she told us.

For a while we all smelled of tea tree, or eucalyptus, or medical shampoo. Some of us covered it up better than others. We made the friend who was responsible write us an apology. She said it wasn't her fault that we all had such delicious blood. Then she said sorry.

I was the first of us to get a boyfriend, and within a month of our dating he had nits too. I told him, 'Welcome to the Sisterhood'. A few days later all the nits were gone. They never came back.

I grow split ends and ask one of my friends to cut my hair. She sits me on a chair in the front yard of her flat. I tell her just a trim. She holds the scissors close to my scalp and snips at the air. I shriek and she laughs, patting my head. The blackness of my hair soaks up the entire sun. It falls hot over my shoulders, like clothes fresh out of the dryer. We talk about shampoo bars and dandruff and vinegar rinses. We talk about that time she wanted to get her hair cut like Diane from *Trainspotting*. A few days before the school ball she went to a barber where hair cuts cost $20. They told her they couldn't cut her hair because she was a girl, but eventually she convinced them. She really

did look like Diane. We talk about the photo of all of us on the dance floor, with our arms around each other and our heads pressed together. Two of us nearly kissed in that circle, but the others never knew about it. We look like nothing could ever separate us. We look like girls giving each other nits.

ANNA RANKIN

In Te Wairoa

Every landscape is ideological. Meaning what? Meaning a few things: that our environments always allude to something else, and that we're always projecting some idea of ourselves onto it. Place goes beyond the specificity of the site itself; it's often about you and your relationship to your idea of it. A place orients one's thinking. A land can also be a horizon.

When I moved from the city to Te Wairoa, a small town on the east coast of Te-Ika-a-Māui, I knew I was entering a place charged with a quiet vitality visible only to those with their antennae up. So often friends would lightly jeer at what they saw as my peculiar love for small-town (synonymous with conservative, boring, as though it evinced a lack of ambition, I suppose) New Zealand—but I left with an education that would leave me irrevocably stained in far more loving and thus far more sorrowful ways than those alluring cities of New York, Los Angeles and Berlin ever did.

To me, the town and greater region of Te Wairoa is what might be called a *thin place*. While the idea itself resides in many indigenous and religious frameworks, this particular term is attributed to ancient pagan Celts, who used it to describe sites where there is a threshold between the seen and the divine of the unseen, where a human with their ability to apprehend and receive what's being transmitted may be the bridge between these worlds. A *thin place* is both solemn and stirring and is entirely subjective. It might be presumed that sacred experiences are contained within old churches and historical sites of significance, where they're often weighed down with human history. Rather, these encounters often arise in places of hyper-nature, removed from human intervention. They're where the atmosphere hums with an unmistakable arresting and pliable energy, where we experience something undefinably fertile and visceral. I've come across this in the region I am writing about, the desert, with its electrical charge of absence and presence, and an empty, cavernous airport in Las Vegas.

Te Wairoa and its surrounds have suffered myriad inter-generational forms of tragedy marked by Pākehā colonisation. Some days I'd leave the newsroom, where I worked for just under a year as a journalist, and sob. I had never seen such abject poverty and injustice. Much of it remained locked behind doors I never passed through. Where there was progressive thinking in the area, mostly to do with environmental and socio-cultural initiatives, there were equal amounts of loss and devastation and interconnected iniquity.

People often assume there's a certain sensibility lacking in a town like Te Wairoa. I sometimes wonder what art can do to intervene in a world hinged upon and hyper-mediated by image and data flows and machinations of capital, added value and extraction. Now and then I'm reminded that it can inject an imaginative engagement with the world that would otherwise translate experience as purely utilitarian. To assume Te Wairoa has an artlessness is to have stopped at an aesthetic apprehension of the place. Here is an example of what I mean: there is a painting on the wall. The aesthetic experience holds that you admire it for its surface qualities and sensory properties; the ethical encounter is that you may wonder how it was made, at what cost, and to whom, and why it's hanging where it is—is it a museum or a wealthy person's home? And the mystical experience is that this encounter produces a private impulse within you to make a work of art yourself. Neither is bad or wrong or even chronological; they rely on each other to produce an authentic and deep encounter with something, a felt truth. In writing about aesthetics in art, Adorno suggests the encounter is not premised on understanding the meaning of a work, but rather feeling its necessity.

Like many writers I question how and why writing matters in an age suffocating with hypertrophied content. I'm cautious in making a statement of fact about the present because it is so amorphous and accelerating at such a dizzying pace.

What I do know, though, is that in Te Wairoa I was able to see the welfare of others as inextricably linked to my own. In cities I could choose anonymity and facilitate most things on my own terms; in Te Wairoa to live as an atomised individual was impossible. Time decelerated and something crystallised there, and I am still examining the gleaming facets.

I think many of us are afraid to admit we don't know, afraid of asking the wrong question, thereby revealing our ignorance and being judged for this. I

was wrong all the time in Te Wairoa; I constantly had to ask questions and make mistakes and faux pas. I didn't know anything; everything I'd known was supplanted by a new education both immediate and deep, to do with the environment and to do with how people live. I was offered a kind of ecological and biological literacy. There's probably nowhere else I've screwed up as much. There was so much I didn't understand, that I still don't.

In part, what appealed about journalism was the requisite witnessing and recording and the licence it affords to look with direct intent. It's like what Barthes says: you first fall in love with the scene.

Giorgio Agamben provides an expansion on this when he argues that *the contemporary is he who firmly holds his gaze on his own time so as to perceive not its light, but rather its darkness.* This hypothetical person is one who is able to both see and dip their pen in the obscurity of the present, thereby resisting being blinded by the lights of the century, and so stealing glimpses of the shadows in those lights. There is, he writes, an anachronism that permits us to grasp our time in the form of a 'too soon' that is also a 'too late' of an 'already' that is also a 'not yet'. Our time needs a shadow, he writes. I think Te Wairoa is a shadow.

Te Wairoa is where I was untimely, out of sync with the rest of the world, and therefore I could see a little more clearly, a little more closely. There are interesting convergences of the that-which-has-been and the not-yet in a place that is progressive in some respects, and deeply regressive and stuck at a junction in others. The difference to city living being that here you have to rub up against each other, whether it's smooth or chafing, despite the impasse. Which makes for a completely different kind of community.

I'm certain that not all small towns are like this. But there's an apparent magic to this place; it's no wonder many who live there have moved from overseas or elsewhere around the country. It's almost impossible to explain its magnetism, which is why it interests me so greatly. I think there are some relevant points made by Agamben that might testify to a place like Te Wairoa as being a kind of emancipatory site: a place where there is potential to formulate a new kind of society that has its foundations in Mātauranga Māori and Te Ao Māori, one that wrenches the present into the that-which-is-to-come. There is evidence of this in the council's agenda to make the town fully bilingual in the next twenty years. I'm sure it will be sooner.

Many of my peers and friends and I can trace some parts of our lineage back to colonial settlers, and I query the ways in which we've re-enacted this inherited impulse in our own time, if we've examined it at all. For many of us it is held at bay; it's a secret shame to stem from colonisers so we refuse to look at it. If we looked at it, perhaps we would feel moved, if not to atone, then to return to those what we took, which is land, which is our time, our affective states, our comforts, our education and other affordances given to the middle and upper classes in cities. The psychological condition of uncertainty and placelesssness means colonial settlers never have a solid idea of what we are; we've only seen ourselves partially. What are we still colonising? And what parts of ourselves are we colonising?

I often ask why these same friends and I are committed to remaining in cities we can't afford rather than repopulating hollowed-out towns that need us and all the privileges we've received. Forgoing comfort is hard work and the costs are infinite and difficult but it is necessary, and I am plagued by the thought that choosing my comforts and little luxuries over the equity dictated by reason and conscience misses the mark.

Even though I am not from there—I was not born there, it is not my land—my body remembers this place. I had the sense of being both profoundly alert and deeply submerged there. A year or so ago I was digging around in the dirt for bulbs with my aunt—my mother's sister. All growth happens in the dark, she said as she pressed her hands into damp soil. The tomb offers evidence of what it does not contain, she mused. I mentally packed this away and later wrote it into my notebook. A woman who is interested in Catholic traditions, she told me that physically performing the Stations of the Cross, and many other liturgical traditions across the world's religions, such as kneeling or lying down or bowing or standing or responding in some way with the body, can be emotionally as well as physically painful. Re-enactments seem to both dispel and transmit something. The same may be said of poetry, which a poet-theologian I read described as being able to hold the things in us that feel formless, and that the language of poetry is intestinal, not cosmetic.

The light the sun the storms the skies. Whitebait wattle willow riverbank horses. Flies mosquito sirens. Stillness muddy river green flash of the sun. Storm-sky weathervane poplar chain-fence scooped out earth. Valley wetland

fishing-line sludge. In the spaces between these words I could plug a cord into a socket and turn the lamp on, lighting up the region in my mind. For it, I have a durable vocabulary that rolls off the tongue: I don't have this kind of indexical memory for anywhere else on the planet. I could drive those roads blindfolded.

Everyone knows you can't glean anything close to a central truth as a visitor, as a tourist, or as a journalist. But the latter got me pretty close—got me inside and gave me a reason to ask questions I'd have been unable to had I not had a place to put these. With a notebook and pen I could walk the streets sheltered by purpose and intent. And each night, as a dutiful scrivener, I'd sit at my table on the cream sheepskin my colleague Ann's partner sheared a fluffy sheep for and with fidelity transcribe my notes taken during the day. Notes hastily scribbled between jobs, not relegated to the paper, but those I'd pack away and, hopefully, pull out and look over, even if only to reminisce, if only as a tonic. I did sense they were foreshadowing an as-yet unknown lesson. It seemed my references belonged to two not oppositional but countervailing worlds—the small town and the large city—and the problem was how to find the shadows and the light in each. And the problem of where to belong.

I have lived in sixteen different rooms over the past four and a half years. I have a kind of vagrancy that makes some friends wary. You always leave. You're always thinking on your feet. You're so unsettled. You are so unsatisfied. I take this to be a dispassionate moral indictment. It's true that I know how to spin on a dime. My parents warned me against belonging. They had visionary ideas; they moved and set up and moved. Go to the margins, they said. Both psychological and geographical. The idea was that to belong meant you'd assimilated in some way, and that was risky. Now, I wonder what historical filiation was being re-enacted. To constantly navigate in an adaptive way is also to try to claim or render something in one's own image.

I re-read the notes that I scribbled each night after work with the same fondness I felt when looking down over the glimmering lights of whatever city and whatever love I'd just left from the window of a plane, high above. Or I thought of these notes as like tuning the dial on an old radio, the signal barely perceptible under the fuzz. Sometimes I wonder whether they'll be the dog days of my life. The seasons turned like reams of paper. They have the

ease of a long sequence of filmic dissolves that I make sure to play from time to time so that the colour doesn't fade.

There, in that place and in that life, I found I began a process of formally recovering my beliefs, through transgressions and failures and various reckonings. I viewed my own arrival there with interest. I began to sense that I could value an experience not only for what it might teach or offer, but for what alternative possibility might arise. Remorse is a good animating force, I think. So are confusion, walking, swimming and driving. And writing. Some people believe that stones left on graves let the dead rest, and flowers bring them back to life. A pen is a flower, the mind a stone.

Te Wairoa gave me a life that still blooms, and it gave me, a person so terrified to ever truly arrive, the only home I've felt close to knowing, which made and undid me, like spirit and matter. It sounds excessive because it is. I've used the word *abundant* more than any other adjective to describe the place. It just falls out of my mouth before I can clamp my hand over it. And then some, usually those who've not been there, accuse me of being maudlin as though I'm describing Plato's Academy and all I can do is shrug, agree and try to temper it with the facts.

Postcards From Home
WALKING
I moved into a two-bedroom state house with white weatherboard cladding on the main road into town. It was owned by a couple the same age as me. I had only viewed it online, and signed the rental lease. The weekly rent would cost just over half my wage. It was warm, sturdy, and it had a shed in which I found a sawn-off shotgun stashed, on my first night there.

I would grow used to the sound of people creeping around the property at night; there came to be a kind of comfort to it. A back door in my kitchen opened to a little doorstep that was always baked in sun, especially in the mornings. I sat there most mornings and read with my coffee before work, stretching my legs out in the sun and looking at the sky to predict the weather. There was a metal farm gate across the drive that must have been used to tie reins to. Living alone, in my own house, was better than I could have ever imagined. It smelled like shade, sun and the old wooden floorboards underneath the carpet.

Across the road lived a woman who had an incredible rose bush that climbed over her white picket fence. Ivy threaded a metal archway. I used to stop and smell the pink rose blooms, which were so full and sweetly scented that I figured they must have been grafted from an ancient bush. One evening she yelled out and told me I could pick one.

Roses are my favourite flower, not only for their beauty and form but because they allege that love and beauty are as afflictive as the prick of a thorn on a finger, because they bloom best under a cold frost and so come up brighter, their petals shaped as though sliced out of ice. Pruning urges their growth, and as their thorns increase in size so does their bouquet. Their latent force is in the trace of scent, what they leave behind, a current of sweetness. One of my many bottles of perfume is called Rose of No Man's Land. When I read these words carefully I am struck by their layers of meaning. I can't walk past a rose and not want to bury my entire face in it.

WEATHER

I always wanted to live in a place of weather, of marked seasons, and a place near the sea. The weather over the sea. When I was a child, in our house by the ocean, my father would draw open the blinds and switch off the lights during electrical storms. We would stand in front of the large glass panes in the darkened room and watch the pink lightning crack over the black sea. His arms would be folded, his smile lit up. The rumble of thunder and our silent counting in between the low roar and the crack.

I wanted to be a weather girl so I carefully studied the contours and patterned marks and symbols on the back page of the newspaper. I asked my father what each implied, and I remembered his answers. I understood the flow of currents, why cliffs eroded into white rock that crumbled into the sea, the push of the swell in the deepest ocean that would surge onto the beach on the tide and the wind. The front that would carry heat or heavy rain. The offshore wind that held waves back, the onshore turning the beach to a white mush of chopped waves. A high over the country meant long days of heat but no surf for my father.

I copied the same pictures from the paper and drew our island home. I plotted out pressure systems and drew the flux of weather with felt-tip pen: storm days, or a week of scorching sun. I preferred extremities and I still do. I

taped the pictures to the front of the small TV and tapped on each region in turn with a long bamboo stick, the one my parents would strike us with when we deserved it. Here it will rain violently—and I placed the stick on the coast. Here is where snow will fall. Here the heat will burn.

My family were sometimes willing participants of my little show. I once performed it for a woman who looked after us children for several weeks when my parents were off somewhere. Oh, she said, you must be a weather girl when you grow up. Her words were how the idea was implanted; I'd not attached a profession to an imaginative curiosity. It was a kind of magic; I wanted to make and master the world. Memories are fused in sun. The world dries out. Rain pours, the world turns to water. Cold weather becomes a memory, the air smells like pine, thoughts like reels of film.

Simone Weil says that attention is prayer, and that residing in this subjunctive state means waiting for something to manifest itself through this act. What follows, then, is that prayer is many things, not only words. I think finding a container for prayer is more to the point; it needs a form, and that form can be embodied, like walking, like driving. To wait suggests a kind of radical faith in the promise of the unseen, and I recognise this as caring for what you see and feel by scripting it into existence. It occurs to me that lists and notes composed inside private notebooks are a kind of non-arrival, an in-between. More than prosaic assemblages of reminders or observances, they are both automatic and instinctual, and become radioactive and gestate over time. My impulse to record is a strange one and seems prompted by a sense of both loss and affection, and the need for an antidote to loneliness. I would like to learn how to belong, despite not knowing where I am from, despite feeling placeless.

While I no longer live in Te Wairoa, I still take this drive as often as I can afford. The re-enactment of this journey is one of my favourite activities, and it feels like a sealed ritual, where I can access a state of heightened awareness through the transit of time and the thoughts that roll alongside. Memory requires more than mere recollection; it necessitates reliving as an act of expectation and anticipation, and this journey feels like an observance. My mind wanders on this drive. Tidal waves of memory keep me awake. I remember sweating through the sheets and the rain lashing the window. The

wind blew ferocious and it raced down the hallway. Rain poured through the crack in an open window and the next day I laid out my clothes to dry on baked concrete. Shaken like a snow globe, the scene is obscured by tiny particles. The language of ghosts. Sometimes I am derailed by my mind and the lines it draws, the patterns it shapes. Thoughts strike like sharpened arrows. Does remembering ever quell the heart? It is quenchless.

Etel Adnan says we leave a place in order to stay, and this couldn't be more appropriate, though I think I'll shore back up there one day. Brief sketches drawn contain another and another; every event is a door into another story that I will never be done with. Is it possible to ever truly reside where one is? It all sweeps by like cinders. This place is one I return to on certain evenings when the sun turns its belly over from gold to bronze-green as it did throughout the seasons there, and I look across the canyon from where I now live and watch smoke curl up and out from the chimneys below. I recall my repeated and frustrated attempts to light a fire that lasted longer than five minutes: an uninitiated but relentlessly curious young woman stuffing balled-up newspaper and twigs into a fireplace that, after a month of my trying and refusing to ask for assistance, finally lit.

JOHN DENNISON

Reserve

Halfway in, I stopped. The unsure path
had hazarded a way beside the stream
choked with fall, the reserve's split and pith;

now, it faltered where the wash from
a small valley's open palm met
the clay rut of a gully. I'd no frame

for this. Some kids' campfire splayed in rot.
The sky-bearing clarity of a trickle
surfaced where I had meant

to step, sending its fraying wet to tickle
the pugging creek, scarp its opened side.
The wasted thought of a fence: a wire ruckle

in the moss. Everything was inclined.
But though massive gouged tawa, with muscular
twists, upend an earthed air skyward

and remain—remember for you where you are—
I had stepped into a grief out of place,
lost in the understorey. A grey warbler

laid down loops in the tops. Sparse
kawakawa sequined in the air cold
down the stream as trees made space

acute, a holy lofting. *The word is behold*
is the word. Yes. And there is the waste
gravel heave, for sure, the barbed wire rolled,

the nipped-out ends of fern, my face like a fist
unclenching. And: *already I saw you*—not just saying
this—*already inclining is more than you guessed.*

And: *look, here comes one with a face like a clearing.*

BRETT GARTRELL

Binary

We used to count slowly,
unfurling each finger
steady as a metronome
ticking off beats
synchronising
our digits together
in 4/4 time.
Enumerating
the base ten code,
though some believe
the most complex
convoluted tangle
of chaotic data
can be reduced
to a set of switches
that oscillate between
two binary settings.
Off and on.
Zero and one.
They say memory
might be as simple as this:
A channel in a cell membrane
receptive to an impulse
deep in the cortex
shuttling between two positions
suddenly evoking
the sharp iron smell
of umbilical blood
as you cut his cord,

the velvet feel of a comfort blanket
lost in the wash,
or the warm slippery soap
running through your fingers
as you bathe his head,
the boy's first bath.
Think of it: all sensation, literacy, numeracy
contingent on a simple neuronal spark
that can fail to ignite, or reignite,
As it fails us now:
my thumb unfurls
and he touches it,
eyes wide,
the concept of One
fading like

an old map
you thought
would take you both
somewhere new
but whose once divergent paths
now coalesce
into a simple choice:
Stop, or go on.

WES LEE

New Age

The apartment where I grieved your death—
the initial grief, the storm grief—
I drive by and sometimes forget to look up
at that top-floor window where I spent
so much time staring out.
The library's spiritual section where I trawled
New Age books on death and the afterlife,
on NDEs, with titles like *Hello from Heaven!*
The butterflies I saw printed everywhere,
on T-shirts, postcards—*Pieris rapae* alighted
on a cherry blossom sprig, its wings
soured to cream from the translucent white
that called to me one afternoon in the gift shop.
The ways we latch on to what we feel are
communications from the dead; scientists,
philosophers would call it something else—
the way doctors explain away the white light
seen from those reporting back (cells in the
brain shutting down, the kaleidoscope's
last bright pinhole), those whose bodies
have floated to the branches of a tree at the
accident scene, the ceiling
from the operating table, those who have
seen things they could not have seen.
Like the boy, six minutes dead,
who rose from the gurney
up up up to the top floor of the hospital
and saw a shoe outside on the window ledge.
Back in his body, when able to walk,

he pushed his IV along the corridors
to peer into rooms and finally stare
at that shoe. A man's brogue.

ELIZABETH SMITHER

The Whistle Dress

I buy a new black dress
made by Whistle. It's the sort
shop girls wear who have to buy
their own clothing: plain and black
serviceable with a trace of chic.

That trace is at the back: a gap
in the shape of a diamond
with a strap across: nothing
that requires extra expenditure
in the lingerie department: black

bra. I have a drawerful of black
knickers. Be careful lest you get
run over by a bus, my mother said
so that's the reason for black: a
mess looks better when it's obliterated.

It's the last Whistle on the rack.
The staff have been buying them
wholesale the black-clad assistant
says. You'll find it serviceable.
If I could see the back I'd whistle.

MEDB CHARLETON

I Think I Saw You Dreaming

one night, ripe, round and plump,
soft as a fig, a garden in your exhale
with swallows just asleep, near stillness
in the chestnut's candelabra,
 buds like baby nails, new moons;
 a chemical emporium in the leaves—
 rest there until the avant-garde bees
 come to suckle at coffee time

JEREMY ROBERTS

Apology to Kendrick Smithyman

You poor bastard—
question after question greeted with nervous, blank faces
during those Friday afternoon tutorials
at the Uni of A.
You'd seen it all before.
It was only '78, but your spaceship had long since
left student mediocrity behind.
We weren't even queer for words, yet.
I did eventually make a start, Kendrick—
the results of which are hidden away in an envelope
marked 'Humble Beginnings'.
I never forgot you
& you're still miles ahead.
Apologies for sounding a bit juvenile—
but, what's it like being dead?
Are you still creating those dizzying mosaics?
(On the grassy banks of Heaven?)

TIM GRGEC

Pixelated

'If I were mad, I should forget my son.'
—Constance, *King John*, III. iv

I'm tired of FaceTiming my dead mother,
 with the strange time difference and everything—
 how she usually forgets to turn the sound on, or wear headphones
so I can hear the echo
of my own voice.

 It's somehow late for both of us, as she tells me about the exotic food,
the locals climbing each cliff on horseback.
 Her lips move faster than the words, as if the connection slows her down,
 talking over herself about current affairs and books read
 just to get it said in time.

My mother's come a long way, considering smartphones weren't even around
 when she passed,
though now her arm gets sore from holding it up
 in the night.

I show her our tabby cat who's returned home
after all these years, like it hadn't really been missing at all
 just wandering in order to come back.

My mother reminds me to cover my mouth when I yawn, apologising, again,
 for interrupting my sleep.

GAIL INGRAM

The Kitchen

On the splashback, delineated flax leaves fan
like torch beams trained to the night sky
losing light. Wilfully, you polish
the oven, dewlap quivering
with the thin humming that seems
not to originate from the reeds of your throat
but somewhere near the ceiling fan.

I remember the crisply tied bow
of the apron at your back, as you lifted
neat rows of Kisses from the shining rack; your energy
crackling as you kept your distance from childish dirt
that we must flick away. Let me wash,
you dry. Side by side at the sink,
buff the spots, let the gleaming link.

JESSICA LE BAS

The Photo He Took of Her Beside a Man Dressed as a Priest (1983)

'Fictions of our consciousness,
We've laid instinct and knowledge to rest ...'
 —Fernando Pessoa, 1925

In imagining she is young again
her heels, her bone china face—
There is nothing of the years on her hips
if she just keeps her mind on
other matters; the lift in her chin
where her hair falls to her shoulders,
like there is no wind, no winter
storm brewing. And inside blood is blood;
nothing's changed. The same furniture
of worry, the same wishful wall hangings,
bright with beauty, something on a far horizon
vanishing; gone. Inside, a banker's vault, an
indeterminate currency; the ready cash
of wit, the loose change of hard knocks
—and heartbreak
Inflation has taken over now. She imagines
she is back there, and in the imagining moves
outside, and into something altogether
unimaginable. Her cheeks glow.
Soon, a fire. Ash as soft as the thrush's song.
Only a handful of dirt.

ARIHIA LATHAM

Waitangi

for my Nan

Today's long white clouds
Are the damp sheets
Pulled tight by
Our raw knuckles.
This big tub
Needs us to feed
The wringer with
These forcibly immersed
Sodden shapes.
Our arms ache
As we squeeze out
All that today requires.
Despite our rubbed red hands
These stains
Fly above us
On the breeze.

NGAHUIA HARRISON

Te Tangi o te Moana

When her hair turns from the rivers, the tide is leaving the harbour, you look to me and ask what will be left?

1. He tai ora
2–3. Manu & Kahu
4–5. Rīpeka
6–7. Whakaheke ngā roimata
8. He tai timu

(All photographs 241 x 359 mm.)

My parents live at Whangarei Heads. That is right beneath Manaia, our eponymous ancestor. It's also right across from the Marsden Point Oil Refinery that employed my granddad, dad, uncles, cousins; which is right along from North Port, where many more of my whānau worked.

There are different cosmogony narratives for us (Ngātiwai) describing how our sacred harbour was formed by and from our ancestors, so that we could sustain ourselves here.

The refinery site was chosen as it is beside a deep-water port and in a low earthquake zone. Now, in the Anthropocene, neither of those features is true of this place. And we, the descendants of Manaia, who has overlooked all history and construction, have taken part in its wreckage. With the potential port expansion project looming, there is an urgency for uri of this water to start listening to our tides lamenting.

As a response to climate crisis many people are looking to indigenous knowledge systems, but even we are re-learning mātauranga that was lost. Colonisation means being made an alien to our own ways of being, from our language and our maramataka, which taught us not only about harvesting, but also about allowing ecosystems, human and non-human, the chance to replenish and restore.

— Ngahuia Harrison

Landslide Country

The sign indicating Highway 51 rattled on its loose screws in the gentle breeze. The red shield had a couple of holes that might have been the result of bullets.

Ange Campbell sat in the over-cooled air in the bus's quiet interior. The driver had somehow failed to notice that they were heading into a mountain pass surrounded by banks of snow. He had the air-conditioning dialled beyond refrigerator. The engine stayed idling to keep the air running. A dull thrum came through the seats.

He'd parked, here at the lookout, and wandered off with every other passenger so they could photograph the falls.

There they were, at the Armco barrier, leaning against it 50 metres in front of the bus. Phones up, photographing themselves. To think of all those years wasted photographing other people. She could have just pointed the camera at herself.

Ange had come through here with Thom twenty years back. It seemed unlikely anything much would have changed. A veil of water dropping eighty metres, its base vanishing in a white haze around fallen rock and dancing ferns. She had her own photographs. Prints, rather than something ephemeral on a screen.

Anyway, she liked the quiet. The journey from Meadville had been a riot of twenty-somethings oohing and aahing at the scenery, having loud conversations and tapping at their phones. Digging into bags of Doritos and nut mix, cracking cans of Coke and Fanta. Flirting and play-fighting. Backpackers, mostly. One family, with a, what, twelve-year-old? She was a sharp kid. Holding her own with the group.

Their energy was great. Invigorating. But it was nice to have a moment's peace.

The bus had to be thirty years old. It had lasted longer than her marriage. The local school bus she'd regularly driven into Glenvale all those years back

had been in better shape. And that was before all the modern safety rules.

The interior smelled oily. The seats might have once had patterns but were now mostly a uniform grey-green. Beyond any help from cleaning products. Threadbare in places. Periodically on the ride up a spring had dug into her back. Ange had balled up her scarf and tucked it in.

She'd come dressed for the cold. Thick socks and hiking boots. Thermal trousers that breathed, supposedly, with one of her old *Kiss* tour T-shirts— well loved and a pleasant reminder of better times—with a royal-blue hand-knit jersey, NorthFace beanie and a good jacket. She hadn't expected to have to wear the jacket aboard the bus.

The windows were slightly crazed, as if someone had given them a light polish with fine sandpaper. Ange half-watched the group out on the lookout. Facing away from the view with their phones held before them. Arms around each other, grinning and laughing, sunglasses glinting with the winter sun. The falls rose high behind. The surface of the deep pool not far below the safety barrier.

Ange rubbed her thighs. She probably should have got out with the others. Stretched her legs. What would her mother have said? *Get the kinks out.*

Ange stood. She pulled on the cold chrome rail on the back of the seat in front and stepped into the aisle. An empty can lay on its side, a little dark liquid dribbling out. Ange bent and picked it up. She put it into the netting pocket in the back of the seat in front of hers, with the balled-up kebab wrap and other rubbish.

From outside, one of the tourists yelped. Then another. Ange crouched to see a dark green bird darting across in front of the bus. A kea. And another one. One of them called, loud and piercing.

Another sound too. A deep rumble over the noise of the bus engine. Some passengers were screaming too—a cacophony, but little different from their shenanigans in the bus.

Yet there was something else—an edge.

Anticipation.

Had someone fallen? Ange hurried along the aisle. No surprise really, the way they were practically leaning over the guardrail trying to get the best shot.

Now she could see it. To the right, across and beyond the falls, part of the slope had given way. Rocks tumbling down, spinning like sideways tops. But

above that was the real issue: a huge chunk of slope had broken loose like a raft of greenery. Trees and grasses.

Moving slowly.

It was huge—the area of a football field perhaps. And making a slow turn counterclockwise. It was poised right over the pool below.

Between the shifting vegetation and the water stood a sheer, rocky cliff. Dug out over eons by the relentless water.

The edges of the chunk began tipping over the cliff's edge. Draping like a cloth over the side of a table. The far side was perhaps two hundred metres away.

More young people were yelling now. Excited. Taking photographs. Leaning out across the barrier.

There were a lot of birds in the air. Dark shapes, big and small amid the shifting, tilting trees. Circling and hovering like flies over waste.

The sound was remarkable: a grinding, wrenching. The sound of something tearing apart.

The mass of greenery shuddered. Slowed. More rocks spilled to the waiting water. Dusty streams of soil wafted from the edges.

Ange stepped from the bus and dropped onto the crunchy gravel.

She waved to catch the attention of the driver. 'We should go,' she called.

'And miss this?' he said. He was a wiry man, perhaps seventy-five, with thick grey hair and a bristly moustache.

'Exactly,' Ange said. 'We need to miss this. It's not safe.'

'The kids love it.'

He was right. The kids did love it. They were photographing madly. Videoing too, holding their phones out, trying to keep steady.

'Hey!' Ange called. 'Get back from the edge. Get back on the bus.'

A couple of them looked around at her, eyebrows raised. Then went back to photographing.

'Please,' said Ange. 'It's not safe!'

She sounded like someone's panicky old grandmother. *Come away from the water, little ones, you might drown.*

Maybe she was being panicky. The vegetation raft seemed to have come to a standstill. Occasional rocks and clumps of soil fell from its exposed edge.

The bus had no seatbelts, but she bet that if it did, she would be the only

person wearing one. Maybe the family would insist that twelve-year-old wore hers. How uncool.

Mostly it didn't matter. Mostly buses didn't crash. But if one ever did, Ange wanted to be ready. Safe.

The air had a brittle tang to it. Her nostrils crinkled.

She went right up to the driver. 'We should get on the road,' she said.

'We're ahead of schedule,' he told her. His breath was strong. Mints. 'We have time for some photos.'

'They've taken their photos now. We should get on the road. That doesn't look safe.'

'These mountain passes can be dangerous,' someone else said. The twelve-year-old's father. Late thirties, head shaved to the scalp with no hat, and wearing shorts. One of those people who didn't feel the cold.

'The landslide is across the valley,' the driver said to Ange. 'What do you think? That it's going to fly over here and crush us?'

She should be used to people speaking to her like that. As if she didn't know what she was talking about. Just some doddery old thing who should get out of the way.

But she would never get used to it. And she would never stand for it.

'I don't think it's going to fly over here,' she said. 'That's idiot talk.'

The father sniggered.

'But I do think,' Ange went on, 'that it's precarious. A landslide on that side could trigger another one on this side. If the slopes are unstable, we don't want to be here.'

The slope above the road was less steep than the other side, but still bore scars and depressions from previous landslides.

Old. These things took place over geological time. When they occurred it came with a rush, but the gaps between could be years or decades. Longer.

Then something triggered them. Like rain. There sure had been a whole lot of that lately. From where Ange stood the waterfall was visible, and it was running full and fast. No wonder they wanted photographs.

The slumping raft lurched again.

Ange focused on the father. 'Let's get on the bus,' she said.

'The bus?' He cast a nervous glance at the twelve-year-old and her mother. Both were at the railing watching, though neither was taking photos.

He was right to be sceptical. If something struck the bus it could shunt them all over the side. Better odds on foot.

Moot now. Everything would happen in the space of seconds.

Across the valley the vegetation raft made a grating sound. It shifted, slipped further.

When it went, it would go fast.

'Come away from the edge,' Ange called. '*Please.*'

Some threw her looks that said, *What are you, my mother?* Others lowered their phones and stepped back a little.

'Behind the bus,' Ange said. She couldn't guess at the volume of the mass but it had to be substantial. Not just a veneer. More than overburden. It held whole root systems of trees—big trees. Tall pines and beeches. Tipping and tilting now.

Faster.

There was no telling how much debris it might throw up.

So easy to picture chunks of dirt and rock flying through the air. Snapped branches spearing at them.

Was she overreacting? Some of the others looked a little nervous now.

The ground shivered. A miniature earthquake brought on by the movement. Ripples in a pond.

Ange looked back at the nearer slope. No sign of it giving way. Yet.

She walked around the driver. The mass was edging its way out still. A juvenile pine swung out, pointing almost straight at them, then tore away from the mass. Roots ripping off more chunks of earth. More rocks.

The tree performed a half-flip before impacting the pool below.

As Ange reached the barrier, the water's surface, already churned from the cataract, roiled and swelled. Waves raced across, crashing like the ocean against the rocky near side, then bounced and headed back across the pool. They lashed at the far side, washing away rocks and soil that had fallen from the mass. Downstream, the river surged.

'We should all come away from the edge,' Ange said, raising her voice over the sound of the falls. This was supposed to be a peaceful place. There shouldn't be danger like this.

An Asian youth had a tiny boxy camera on the end of a stick. GoPro, that was the one. He couldn't have been more than eighteen. He was filming it all.

The mass had slowed but it was still on the move. The loss of that smaller tree had caused a shift in the balance. What would happen when the whole thing came down?

Ange looked up. It was barely moving. Perhaps it had stopped.

Maybe it would just break up into smaller pieces, each tree creating its own set of waves. They should all just stand here and watch it.

'You're right,' the father said, coming up beside her.

He put his hand on Ange's shoulder and she tried not to tense up. A stranger touching her. She took a breath.

'I know,' she said. 'This is not safe.'

A young couple were listening. The woman said, 'This is not safe?' German, or perhaps Dutch.

'If that hill's falling apart,' the father said, 'maybe this one will too.'

'Behind the bus,' Ange said again. 'Everyone, *please*. Get back.'

Most kept taking photographs but Ange had a small cluster around her. The German or Dutch couple, the family, the Asian youth who'd lowered his camera on a stick, a few others.

The mass shifted. Lurched forward.

'The bus!' Ange said. 'Now—everyone!'

Time to leave them to it. Just as Thom had left her to it. Fend for yourself. Ange turned and started running. Others followed.

The noise was terrible. A wrenching, grinding, end-of-the-world sound.

She stumbled and fell to her knees. Hands grabbed her arms, shoulders, and pulled her up.

On the slope above the mass another big section had broken away. Amazingly, some people were still at the barrier filming. Laughing.

Ange wanted to shrug off her helpers. *I'm okay. I can do this.* Which brought up other things. *Don't touch me. Leave me alone.*

The bus. Right there.

Then a couple of seconds later—the sound was excruciating. The explosion of a building demolition.

Then, water. A lot of water.

They were behind the bus. The bus driver joined them, as did others. Twenty or thirty in all, pressed up against the cold metal. Some craning up to see through the bus's windows.

From back at the barrier came screams. Crunching on gravel. More screams.

Ange ripped herself from the steadying hands and stepped around the front of the bus.

So much dust, and spray.

And water. A wall of it. Four or more metres high, reaching up as far as the barrier. A lake tsunami.

They were all running for the bus now, except one who was lying by the barrier, clutching her ankle.

Ange ran. Old joints complaining.

The wave dropped. Most of it fell back over the edge, but plenty sloshed on the barrier, on the gravel. Over the young woman with the bad ankle. The water swirled around her and she was in trouble. The water was pushing and pulling her toward the edge.

The water was surprisingly strong.

Ange ran as fast as she could. Six metres ...

She ran, dived and grabbed at the woman's arm. Held on. But the woman's skin was slick and slipped through Ange's fingers. Ange threw her other hand over and grabbed a wrist.

The water pushed them both now ... the barrier right above them. Ange reached up and grabbed it. The metal was wet, slick. Her hand slid down.

She lunged at the gravel. Water ran over her hands.

The woman was under the barrier, half over the edge. Ange scrabbled frantically at the ground.

Something rumbled across the valley.

That second mass of vegetation. Bigger. Sliding. Ready to drop over the edge right into the pool.

There were hands on her. All around. Holding her tight. Holding her down.

Talking. Splashing in the puddles. Hanging over the barrier. Helping the two women back up.

Ange gasped as they pulled her up. She let them help her to her feet. She stared into the valley. The huge slip had just about emptied the pool.

Then with a boom, the second mass crashed down on the first, spreading out over the pool. There was not enough water left to create another wave.

They were still holding her. Someone had produced a blanket from somewhere. Someone else brought a Thermos of coffee.

Dust wafted up from the slips. The air felt suddenly dry and old.

Ange accepted a cup of coffee. People were chattering. Nervous. Relieved.

They were all wet at least to the knees—the water had reached as far as the bus.

The young woman was crying now, leaning into the shoulder of one of the others.

Water dripped from the bus's front bumper.

Ange's coffee was hot and sweet and invigorating. Just the thing.

The bus driver was helping people retrieve their bags to get towels and changes of clothes.

Ange turned to look back. The waterfall tumbled unabated. Water was finding its way across the jumbled debris below.

Someone put an arm around Ange's shoulder. The twelve-year-old's mother.

'Thank you,' the woman said.

'Of course,' Ange said, and introduced herself.

'I'm Ellen,' the woman said. 'That was my other daughter, Sam, that you … She …' Ellen trailed off.

'It's all right,' Ange said, a shiver running through her. She turned and pulled Ellen into a tight hug. 'Glad I was here.'

Ellen cried and Ange held her. When was the last time she'd held someone like this? Had she ever?

And then Ange was crying too. Shuddering. About people so carelessly preoccupied.

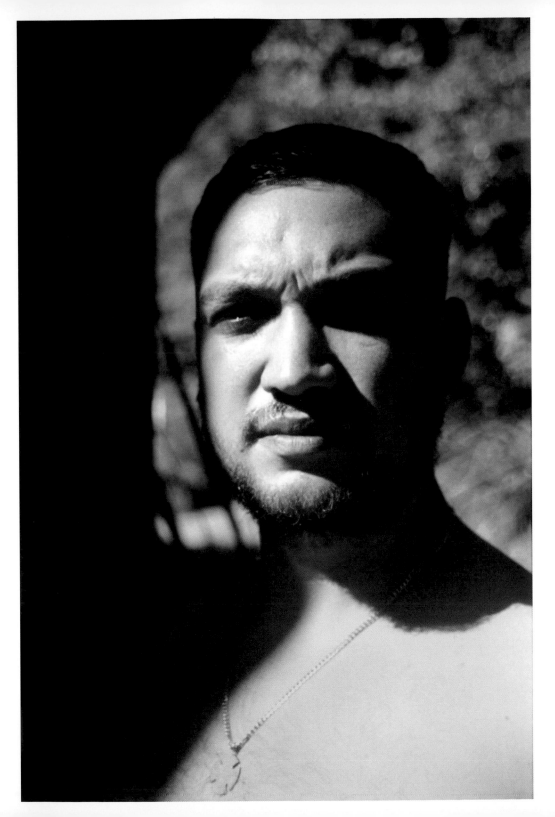

JOHN GALLAS

4 Tramping Tankas

1.
A coat of green moss,
a beanie of cold bright sky,
stout boots of shingle—
I'm away, come rain, come shine,
into the well-known unknown.

2.
What bush-fire is this?
The leaves are flying-scarlet;
Whooping swans like dabs
of ash reel in the cold sky;
the track crackles underfoot.

3.
Pepeketua
sits in his cold mountain stream.
Shadows of speargrass
fence on the windy ripples
where splay-legged spiders ride.

4.
Hang on, mate, I think
there's a wētā on my head.
Piupiu shade the pool.
I lap water in the dark,
nodding my huge antennae.

RACHEL SMITH

The Tender Box

It's on the back counter. Walk past the sleeping dog in the doorway. Wipe
your feet on the mat. It's easy to spot: wooden, painted midday blue with a
slot on the top. Big enough to fit three husked coconuts or your daughter
curled up at night.

Every few days it needs emptying. Tender piles up around here like dust
bunnies under the bed. Most of it comes from the kitchen next door. Wade
through the talk and there's rukau chops warming on the stove. Eat it with
your fingers, mop up sauce with sweet white bread.

It's heavier than you might think. Remember the honeycombed fluff inside
crisp kapok pods? Floated like clouds from our fingertips, but packed down
into pillows that cricked our necks. Like that.

You could carry it. If you wanted to.

Bend your knees, slide the box across the counter until its edge rests
against your heart.

Open it in private. A bathroom cubicle. Or outside is better, down by the
ocean so no one can hear. There's a lock but it's never fastened. Step back as
you open the lid. It'll tumble out quick. Laughter. Milky breath. Echo of
drumbeats. A lover's sigh. Some stories from over the water. Be patient.

When you think it's empty, put your head right inside and check again.
There'll be something in the corner—irregular, grey as midwinter sky. It'll
burn when you touch it but don't let go. It's okay to cry. Lay it on your tongue.
Swallow. Feel it go all the way down, past anything that is possible.

STEPHEN COATES

Betrayal

I was crouching in the doorway, watching. She ripped off her ring, the one
with three diamonds in a row, and flung it across the room. It bounced off the
mirror with a loud crack, then rolled in a circle along the floor until it fell
over. A second ring, plain gold, was tight on her finger and she had trouble
twisting it over her knuckle. She threw awkwardly, from the elbow. He
laughed as it hit him on the shoulder but it wasn't a funny laugh.

'Typical,' he said. 'That's such a cliché.'

'That's right. Sneer at me, tell me how much smarter you are. That's all
you've been doing for the last eight years.'

Her laugh wasn't funny either. It sounded more like a cough. He kicked at
the ring but it was stuck in the fringe of the rug and didn't move.

'Why do you always have to turn it into some kind of soap opera?' he asked.

'What do you want, a debate? Anyway, when was the last time you did
anything spontaneous or original?'

He opened his mouth, closed it, opened it again.

'You want spontaneous and original?'

He undid his belt and fly, wiggled his hips until his trousers fell around his
ankles. Almost pitched over as he raised one knee, so he steadied himself
against the bed while he tugged at his boots. Pulled off his pants and raised
them in front of his face. The two legs made a V with his nose and eyes in the
middle.

'Behold,' he said. 'My trousers. My machine-washable, easy-iron,
guaranteed one hundred percent something, I don't know, trousers. Bought
by you last month because you said I needed another pair for work.'

She was smiling, her teeth jammed together. The veins in his wrists stood
out as he started to pull at the garment. The tips of his ears turned red. She
smiled some more, showing her gums. With a sudden farting noise the
trousers burst apart at the seam. He flinched as the metal tab of the zipper
struck him on the nose. Then he shook the pieces triumphantly and tossed

them towards the ceiling. One caught on the bedpost and hung there. The other lay against the skirting board, folded over on itself like a broken leg.

Her head swung back and forth, her breath coming in short gasps. Her eyes shone with fury and her mouth was scrunched tight. She walked to the plant stand and patted the vase on the second shelf. Her fingers traced the swirls on its smooth surface. A few dried petals floated to the floor as she tilted it gently towards her and caught it in both palms. Without looking at him she opened her hands and dropped it.

It bounced on the carpet and stopped, resting on its side. More petals spilled out, pale blue and purple. He folded his arms and grinned, but his eyes were shining too. She scooped it up and marched to the sliding door. The frame shuddered against the end of the track as she wrenched it open. She stroked the pot again with her free hand before slamming it down on the tiles, where it shattered.

She strode back to her spot by the wardrobe, faced him defiantly. He was blinking rapidly and her jaw was quivering. After a brief lull he snatched up one boot, and a nail file from the basket on the dressing table.

'Happy birthday, Ian,' he said. 'Here's your birthday present. Thank you very much. Except they weren't, were they, because you forgot my birthday, didn't you? You bought me these a week later. They were more than we could afford but you bought them anyway because you felt guilty.'

With the point of the file he scratched a long curve across the leather. Then another line on the other side. Turned the boot around and held it out for her to see. A love heart, bumpy in places and the ends didn't join. He stabbed the tip into the shoe and dragged it backwards, leaving a deep gouge over the heart. Then a second, and a third, crisscrossing each other like a big star. He dangled the boot in front of him by the lace.

'Happy?'

She wrenched open the top drawer of the dresser, so roughly that several pairs of socks tumbled out. Groped inside until she found an envelope, yellow with a fern pattern around the edge. She removed a couple of sheets of paper and brandished them above her head.

'Remember this?' she snarled. Her mascara had created dark smudges on her cheeks. 'You wrote me this on our first anniversary. I told you it was the most beautiful present I ever had.'

She tore the letter down the middle, then again. When the pieces were too small to hold she crammed them into her mouth, chewed them up and spat them out. Scraps of wet paper stuck to her bottom lip and she brushed them away. They mingled with the petals on the floor like confetti.

He nodded sharply. His shirt tails swayed from side to side, showing glimpses of striped underpants. Then he stretched across and took the stuffed dog from the bookcase, held it beside his face like a glove puppet. One pair of sad brown eyes and one pair of angry green ones.

'Hello, Janet,' he squeaked. 'How are you? Look, I've graduated.'

The tassel on the mortarboard bobbed as he waved in her direction. He grabbed a corner of the hat and tugged. It came away easily, leaving a round pink patch underneath, like a bald man in a cartoon. His hand moved to his hip but his trousers weren't there so he tucked the mortarboard in his shirt pocket instead. The puppy looked even sadder without its hat.

He flicked the left ear. It was floppy and soft. He pinched it between his thumb and finger, then pulled it off, tossed it over his shoulder. The other ear followed.

With her sleeve she wiped away a dribble of snot on her upper lip. She was massaging the marks where her rings had been, kneading the skin in anguished circles. Rubbed harder as he turned his wrist so that he and the puppy were nose to nose.

'Byebye,' he whispered to the toy.

He twisted his own neck as if in pain. Squeezing his eyes shut, he gripped the dog's head in one hand, the body in the other. They came apart with a faint pop and he cuddled both parts against his chest.

She looked wildly round the room, searching. Then she stumbled, half running, out to the veranda, unhooked the door of the cage hanging from the beam. The bird panicked, hopping behind the swing and clinging to the wire mesh with its tiny claws. She caught it at the second try. Took a step towards the fence, checked once more that he was watching. She was shaking all over.

'Janet.'

His voice was a moan, too low for her to hear.

'No!' I screamed, sprinting from my hiding place. 'Not Buddy!'

She gave a little leap, thrusting her arms in the air and unclenching her fingers. Buddy dropped towards the grass, fluttering and confused. Then he

flapped his wings frantically, climbing in a jagged spiral. I peered over the windowsill as he disappeared into the pines.

Dad's mouth was wide open but no sound came out. His face was dead white. His left arm was reaching for me, his right pointing towards the park. I thought he was going to start waving them and fly off after Buddy. Mum was staring down at me with a puzzled expression, still balanced on tiptoe like a ballerina.

The wailing seemed to go on forever.

REBECCA HAWKES

If I could breed your cultivar
I'd have you in my garden

I gripped your hand whiteknuckled
as we scuffed through beefy snowdrifts—
dead magnolia blossom

heaped on the pavement
bride-pale & fragrant & going so greasy
underfoot you slipped. I caught you

at the elbow—not so much to right you
as to encourage you to fall
into me. But you fixed yourself

said, that was close.
The blush raged across my body
like a barbarian horde

torching everywhere it passed through.
Because you were a fantasy
I had certain expectations—

Grab me by my hair, drag me
to your lair & do your worst
etceteras. We had the scenery for it—

a backdrop of unmeltable snow.
Snow that could only bruise
& rot. Spring petal perfume turning necrotic

like the breath of a meat-eater, humid
& retchworthy but I kind of wanted it.
Waiting for another gust in my face

to make certain my disgust was legitimate. Sorry
but could I pluck out that muscle flapping loose
in your mouth? Another slimy petal

windblown & useless. I preferred you
quiet as a magnolia cutting, propped
in a jar & dreaming up the tree you could be.

IAIN BRITTON

Life Cycles

from VIGNETTES (II)

landmark

beached high up | arms
outstretched | it stands

in red earth | two
faces fixed

conjoint aspirations
emerging from rock

it involves
a transmigratory

vision of cargo
cults | spirits

on the loose | an albatross
swooping down

dispersing personalities
into airborne ash

rarefied breathings

a flute talks
to hibiscus petals

curling into soft pools
of sound | it flirts

with colours | the
rarefied breathings

of plants | mothers
wash in the sea

children bubble
through gills through

the eyes of fish | a white
dog sniffs the earth

for bones | blackened
after the last meal

The Landfall Review

Landfall Review Online

www.landfallreview.com

Reviews posted since October 2018

(Reviewer's name in brackets)

High and Persistent Play

by John Dennison

Collected Poems by Allen Curnow, eds
Elizabeth Caffin and Terry Sturm (Auckland
University Press, 2017), 384pp, $60

It is among the most ugly of Allen
Curnow's poems: with its skinny,
occasionally forced dimeter quatrains
and strident, unsure voice, 'Et Resurrexit'
unfolds its conceit with about as much
grace and charm as a cardboard carton.
Its conundrum is that of epistemology—
of how we know reality—as provoked by
the church's confession of Jesus'
resurrection, that wonder and sign of the
end of death's rule. Awkward from the
first, the poem plods, stanza by stanza,
through the incapable bodily senses,
each of which fails to verify 'life's in-/
most certainty' before trotting out the
piety:

> We teach it this way,
> sons of men:
> on the third day
> He rose again.

Gangly juvenilia that it is, 'Et
Resurrexit' presents an important
threshold into the work of Curnow, who
is rightly touted on the fly-leaf of this
new Collected Poems as 'among the greatest
twentieth-century poets writing in
English'. The poem is important less for
the way it hints at Curnow's crisis of

theological knowledge than for its
conflicted anticipation of what becomes
a persistent concern of his poetry per se:
a fixation with how we know the world
(senses, signs, reality), and the way in
which that world is both threaded
through with death and troubled by
wonder.

Such fixation is, as Andrew Johnston
has brilliantly established, the hallmark
of Curnow's mature work.[1] The quiet and
prolonged dislocations of Curnow's life
from the late 1940s into the early 60s
were paralleled by a remarkable breaking
and remaking of style, a trajectory amply
charted by Caffin and Sturm's editorial
decisions (including their decision to
incorporate previously uncollected work
from Curnow's silent 1960s). The shift
was not merely thematic but existential,
registering at the level of making. By the
time of the 1972 signpost collection *Trees,
Effigies, Moving Objects*, the measure,
earnest apostrophe and, above all, the
braced first-person plurals of earlier
work give way. What emerges is an
unstable, personally inclined but
habitually ironic voicing, insouciant in its
detached playfulness and obsession with
questions of knowing; and in this, *always*
in command.

Benchmark poems such as 'A Window
Frame', 'Things to Do with Moonlight',
'Dialogue with Four Rocks' and
'Continuum' find a speaker not singing
but stepping detachedly, beside and
around precise impressions of reality and
self and, often, enclosed in a kind of
bach of (un)knowing, Curnow's 'Small

Room with Large Windows'. Increasingly self-reflexive in this predicament, he folds us into the movements of a perceiving mind that is mindful above all of its perceptions; the world and self are always refracted, the glazed speaker testing and reinforcing a radical version of what Charles Taylor describes as the immanent frame of late modernity. Indeed, Taylor's *A Secular Age* offers something of an interpretive key to Curnow's developing thought (it would make a fitting companion to AUP's boxed set of the *Poems* and Sturm's *Allen Curnow: Simply by sailing in a new direction: A biography*).

Given his inwards turn, and insistence—simultaneously playful and trenchant—on the immanent and self-enfolding nature of knowing, Curnow's preoccupation with death is as unsurprising as it is unrelenting. In his calculations of epistemic subtractions, the evidence and fact of death—which is always violent, and which surfaces not simply as an end to life but as life's condition *per se*—constitute a commanding realism, the condition of perception. And even, in his darker moments, *deathwards* is perception's very trajectory; poetry becomes an exercise in figuring—making manifest—the truth of death. While by no means the most brutal of Curnow's poems, nowhere are the twin obsessions of knowing the world and the fixed stare of death more closely enfolded than in the arresting 'You Will Know When You Get There': 'A door / slams, a heavy wave, a door, the sea-floor shudders. / Down you go alone, so late, into the surge-black fissure.' And in *An Incorrigible Music* (1979) such chunked refrains as 'A big one! A big one!'—triumphant cry of the rock fisher turned incongruous *memento mori*—function almost as involuntary congregational responses within wild funereal sequences, the whole volume like a kind of metaphysical poetry of lateness—late modernist, too late to believe; poems cast late in the day; and the fact of it: lateness, its lightly touched or serrated conclusions.

Curnow circles the Cartesian predicament withdrawingly, in repeated poems moving from daily amble through the shamed, telling fidelities of the body, through the various stinks of death to a paned box of the (mis)perceiving self. But even while holding firmly to a dogma of violent realism, there are nonetheless moments when something akin to (*say it!*) wonder and beauty assail his poems with high otherness that even his fetishising of violence cannot entirely displace, even as, by various means (irony, parodic twist, agnostic question, reflexive turn), he works to domesticate such lucidity:

> What's the distance between us all
> as the rosella cries its tricolor
> ricochet, the tacit cliff, Paratohi
> Rock in bullbacked seas, my walking eye
> and a twist of windy cloud.
> —'The Parakeets at Karekare'

Dead at 39 in 1953, Dylan Thomas's world-revelling voice ('bullbacked') here tellingly ghosts his admirer and friend

Curnow (again, see Sturm's *Biography* for a moving account of Curnow's prolonged grief over Thomas's death). The given world, more copious and profound than the darkling plain of his convinced misgivings can allow, still hems Curnow in behind and before, so that moments of felt knowledge that are too wonder-full still surface mid-poem to trouble his last word on things. So much is, of course, a trace element, and not the lode proper, that being altogether more gritty.

Curnow's mature work does yield something new, at first in *A Loop in Lone Kauri Road* (1986), and more concertedly in *Continuum* (1988). While a handful of earlier poems drew on childhood memories, 'A Raised Voice' inaugurates the most important innovation of his later work, a recursive arc back through early moments in which what is remembered and recovered is new. The tender negations and sardonic turns of this poem in which Curnow remembers his father, an Anglican priest, preaching, signal the entrance into Curnow's late work of a new note of humility. The turn to memory (which is a turn, in a stance of trust, to consider the poet's own mortality) allows a state of being beside oneself and one's elders that—being that of the child—is from below, and to which (being a state of self and received history) the poet is already beholden, allowing a child's remembered perspective. So much emerges in 'Survivors', a poem recalling the celebrations in Hagley Park for the 1918 Armistice:

Night falls on an unusual scene of public
Rejoicing. A whole head taller than the
 crowd,
astride my father's nape, I can see the *jets
d'eau* the fire brigade pumps across the lake,
ebulliently spouted, illuminated.

I once asked Nobel laureate Seamus Heaney about New Zealand poetry. Baxter he'd read, of course, but it was Curnow's later poems, published in 1990 by Penguin, that he mentioned as making an impact on him. It may well be that Heaney's *Seeing Things*, a collection celebrated for a number of important poems of childhood remembered, as well as for its shiftiness and preoccupation with (as the title suggests) perception, owes a debt to Curnow and this later turn to childhood.

The clear gift of Caffin and Sturm's editorial work in this new *Collected Poems* is the way it enables such a whole-body, back-boned view of Curnow's singular development. If Curnow's dark realism makes him a tough read at points (particularly those excoriating poems of the mid- and late 1970s), it's worth noting that it also marks him among English-language poets of the last century as an importantly local example of a sustained trajectory from conflicted and misapprehended Christian pieties to this poetics of lateness. There are few other instances of poetic development of this scope and artistic persistence— W.B. Yeats comes to mind as a more inherently conflicted, less publicly cautious example.

It is a measure of Curnow's greatness as a poet that he survived such a

metamorphosis, letting the concerted success of the 40s undergo a palpable formal and sonic dissolution (see *Poems 1949–1957*) into his maturing work. Formally rangy, dressing up and down across registers sometimes within a single line, his becomes an opened voicing, albeit existentially *incurvatus in se*. Archly ludic, the poems display— sometimes show off—an easy intelligence and lithe mastery that belie the actual difficulties of composition (difficulties Sturm's meticulous and lively *Biography* relates). Such high and persistent play, across a full and augmented keyboard of English, sets him apart from his contemporaries locally and globally; and he stands above most Aotearoa-New Zealand poets since. As AUP's publication suggests, he remains, like a difficult elder, unignorable. Best to sit down with him and have it out.

Note

1. Andrew Johnston's piece, 'Late, late Curnow: A mind of winter' is inimitable. The tenderness with which he handles the poet's work suggests the care of a bomb-disposal expert; he fulfils the critic's debt of conflicted love. I'm indebted to his reading of Curnow's oeuvre, particularly the way in which he sets it in conversation with the work of Charles Taylor. In *Journal of New Zealand Literature* 25 (2007), 46–69.

Scruples and Anxieties
by Michael Hulse

Allen Curnow: Simply by sailing in a new direction: A biography by Terry Sturm, ed. Linda Cassells (Auckland University Press, 2017), 718pp, $70

The outline of Allen Curnow's life is broadly familiar. The Timaru-born son of an Anglican clergyman, he decided in 1934, in his early twenties, not to follow his father into the church, and instead worked for most of the 1930s and 40s as a journalist in Christchurch. His first marriage, the births of his three children, and several long-lasting friendships dated from this time. In the 1950s he moved into academic life and to Auckland, where in 1954 he met Jeny Tole, who became his second wife in 1965. His first overseas experience, in the UK and US in 1949–50, effected a change in his sense of the world and of poetry, and that change continued in his last three decades, when travel took Allen and Jeny principally to Europe. The shift of focus away from the US could be seen in the European subject matter of numerous poems from *An Incorrigible Music* on, in his introduction to audiences in Germany, Italy and Spain, and in a succession of UK publications and honours.

In the late 1980s I became interested in writing a critical biography of Curnow, and in 1991 spent five weeks in New

Zealand with family, friends and associates, and also visiting locations— the vicarages and churches of his childhood, Lyttelton Harbour, Christchurch, Karekare and Lone Kauri Road, the Bay of Islands—that were of transparent importance in understanding the man and his poetry. Our friendship had begun in Toronto and been deepened by mail and by days of long conversations in Venice, but now our talks acquired a new dimension, and at times a tape recorder. If that biographical project was later shelved, it was partly because the pressures on my own time were increasing, partly because I felt a New Zealander would be better placed to write the first major study, but partly too because there had been signals, delicate but unmistakable, that the story of Jeny and Allen, of the long decade in which the secret of their private happiness and hopes co-existed with Allen's painful confrontation of the death of his first marriage, was one that they preferred to keep to themselves during their lifetimes.

One achievement of Terry Sturm's outstanding critical biography is its unfailing sensitivity to the scruples and anxieties that governed Curnow's understanding of private life. Charles Brasch observed after Curnow's first overseas absence, 'His real life must go on deep inside him, carefully hidden from other people,' and a reader of this biography will immediately connect that comment with Sturm's assessment of the boy Allen as 'uncommonly fascinated, anxious and occasionally guilty about

what could not be spoken of in the family'. An emphasis on privacy and propriety often goes hand in hand with insecurity: Sturm quotes Curnow's own later view of his 1930 self as 'inadequate', 'scared', 'timid' and 'weak'; discovers 'the personal insecurities behind the mask Curnow adopted in public' in the early 1930s; and, writing of the pattern of his personal relationships, observes 'a deep-seated insecurity and anxiety about betrayal which seems to have its origins in childhood'.

Terry Sturm gets this exactly right. At every stage, from the 'invisible panic' Curnow felt when beginning work on Fleet Street to his 'deeply self-critical' stance in the late poem 'Looking West, Late Afternoon, Low Water', the account offered here of the inner life accords well with the public self and his unceasing struggles in his work with God, with socio-political injustices, with the horrors life can inflict, and with poetry itself.

Among Curnow's personal characteristics were diffidence and care for others, and I found these not merely expressed in his poetry but central to his poetics: knowing could never be an absolute, only a contingent, and poetry was a process of inquiry toward what might be known, rather than an expression of an end-point. Terry Sturm tracks this throughout the writing life, from the time of 'Landfall in Unknown Seas' (where Curnow is described as 'habitually ... unsure' about the quality of his poems), the 'epistemological anxiety'

driving 'Out of Sleep', and the 'deep-seated personal insecurity, loss of confidence and direction' apparent in the poems of the late 1940s, to the 'feelings of anxiety and threat' underlying the poem that set the key signature for the late work, 'Lone Kauri Road'. Beyond that poem lay three decades of poetry born of questing scrutiny: 'The "continuum", one of Curnow's favourite later terms for the world of spatio-temporal contingency, is a saving order, protecting consciousness from the nightmare of non-existence or total solipsistic self-absorption,' writes Sturm, and it is hard to imagine any improvement on this even-handed assessment, which includes Curnow's fears, his abhorrence of self-absorption, his longing for the salvation that his reason told him could not be available, and his fundamental understanding that nothing is fixed, any more than the play of light and wind on water.

It has always been easy to misrepresent Allen Curnow. His strivings to be fair in all his anthology dealings may surprise those eager to assume that those ranged against him were always in the right. More importantly, the much-parroted view of Curnow as a nationalist is quietly demolished here: Curnow saw 'the idea of nationality' as 'the most destructive, most enslaving idea in history' (as he wrote to Douglas Lilburn in 1940), and to Rex Fairburn he observed that what New Zealand needed instead of its centennial pomp was 'a festival of penitence and humiliation'. Writers in New Zealand should write out of the experience of where they found themselves, yes, but not in order to earn a national label: 'Practising artists do not belong among the foundations of the national culture, like so many illustrious corpses below the paving of Westminster Abbey.'

Sometimes Curnow is presented as if he had been at some kind of top—of his profession, his public status, his influence—virtually from the outset, and had become inured to ex cathedra pronouncement. This is fatuous. Sturm's biography is a welcome reminder of how hard-won the presence he achieved really was. The chronicle of the journalist years is a lesson in how hard one might need to work, and for how little return. Follow the money through this narrative—through housing, cars, overseas travel, rare windfalls or grants—and you're following a man whose life was largely lived within a sense of constraint. 'I've opened a tin of sardines,' he announces to Jeny in the Horrocks documentary—hardly the words of the financial ruling class. Economic insecurity conjoined with personal insecurity doesn't lead to any sense of being a master of the universe: in my experience, when Curnow was surprised and pleased about something, such as an honour, the surprise and pleasure were genuine to the point of naivety; when he asked for an opinion of a poem it was because your opinion mattered to him; when he explored philosophies he was unfamiliar

with, and used the results in his writing, it was because the heuristic spirit was second nature, not because he was out to impress or intimidate.

This is a truly indispensable study of Allen Curnow, alert at every step both to the inner life of the man and to the nature, mechanisms and guiding principles of his work and impact as a writer. Sturm gives proper and generous attention to the plays and to the satirical verse published as Whim-Wham. He tracks Curnow's US impact over the two decades of regular contact particularly well. He is judicious and meticulous in tracing Curnow's decision not to take holy orders, and in documenting the correspondence, the positions taken, the understandings and misunderstandings, in his anthology dealings. He conveys Curnow's capacity for friendship, his 'dislike of social pretension of any kind', his antipathy to the abuse of power, to racism and to moral ugliness of any stripe, and his anxieties about meeting his own high standards.

Karl Stead has published his corrective to what he reads as an ill-balanced account of his relations with Curnow, so I'll briefly note a couple of minor errors where the narrative touches on myself: Allen, Jeny and I spent some days together in Venice in 1988 to discuss the contents of his Penguin selection, not possible publication in Germany (which arose some years later); and it was not myself but Vincent O'Sullivan who arranged my 1991 British Council visit to New Zealand.

The main thing, however, is that this biography, skilfully edited into its final shape by Linda Cassells after Terry Sturm's death, is first rate and sets the standard for what may follow.

Cont'd from page 9

Notes

1 'Taniwha': https://teara.govt.nz/en/taniwha/print
2 New Zealand Herald, 'Protesters Occupy Prison Site, Warn of Taniwha Trouble', 2002: www.nzherald.co.nz/nz/news/article.cfm?c_id=1&objectid=3008697
3 Claudia Babirat, 'TANIWHA', New Zealand Geographic, 2010: www.nzgeo.com/stories/taniwha/
4 Elizabeth Binning and Cathy Aronson, 'Second Home Puts Taniwha Out of the Way', 2002: www.nzherald.co.nz/nz/news/article.cfm?c_id=1&objectid=3003507
5 Alastair Bull, 'Taniwha Raises Need for Consultation - Advisor', 2011: www.stuff.co.nz/auckland/news-archived/5124422/Taniwha-raises-need-for-consultation-advisor
6 Michael Laws, 'Monsters and Myths Clog Up Tunnel and Hold Us Back', 2011: www.stuff.co.nz/sunday-star-times/columnists/5128989/Monsters-and-myths-clog-up-tunnel-and-hold-us-back
7 Babirat, 'TANIWHA'.
8 Kepa Morgan, 'Kepa Morgan: Heeding the taniwha can help avert expensive blunders', New Zealand Herald, 2011: www.nzherald.co.nz/nz/news/article.cfm?c_id=1&objectid=10732020

A Radiant Derangement
by Tracey Slaughter

Caroline's Bikini by Kirsty Gunn (Faber & Faber, 2018), 352pp, $32.99

Lovers are readers. Close, in-depth readers, alert to the slightest graze of tone, glance, skin. Their late-night analytics grow hot for every hint of connotation, implication, every shade, cue, nuance. Lovers are urgent critics, hungry reviewers. They know how to pick up traces; they know how to spin wild insinuations of longing from a single unthinking gesture, how to unravel layers of meaning from a word of vague dialogue dropped from a casual lip. In Kirsty Gunn's latest novel *Caroline's Bikini*, the infinite readings—the long fretful sessions of intoxicated over-reading—that lovers enact around their unknowing objects are pinned to the page in exquisite, funny, bittersweet view.

As Gunn's narrator Emily (pet-named Nin) pens the 'novel' of her old friend Evan's passion for another, it's her own disavowed homesickness for him that brims to the surface of this sharp, sparkling, moving, metatextual novel. As Emily charts the ruinous 'nothing' that is her friend's unreturned crush on Caroline, her sketch of his foolish pained fixation—with its futile surges at the faintest non-incident, its hapless inability to reach a declaration—works increasingly to mirror her own untenable

position as futile, silent lover. It's a shrewd dissection of unrequited longing that shivers with sadness, slices with wit, and glints with wry postmodern ironies, yet never fails to register the weight love leaves on the heart.

Emily embarks upon her strange sad project of assembling Evan's non-eventful love-story to a heady 'leitmotif' of gin. Indeed Gunn's novel—in a breathtaking, risky and self-referential airiness of actual structure—is simply a series of chats over G&Ts at bars. A succession of bars stage the characters' encounters amidst the 'chic backwaters' of West London, moving from pubs with 'Labrador ambience and raincoats' to 'slick establishments' of glassy deconstruction where the artisan gins are lavishly 'accessorised' and graced with 'labels that had haikus on them'. The fancified drinks, with their comically pretentious 'slivers of a citrus gesture', are far more elaborate than the plot-points Emily desperately tries to knock into shape as she quizzes the lovesick Evan for more details of his star-crossed entanglement with the distant Caroline.

But although their 'project' meetings are dizzyingly frequent, punctuated by 'six or so' stiff cocktails at a time, the story that Evan has pleaded with his old friend Nin to pull into presentable format—furnishing her with files of his notes and reflections, and divulging still more wish-inflated details in their perpetual 'Q and A sessions'—never seems to progress beyond the lustrous reprise of lightweight incidentals. There

is the 'BANG' of his initial introduction to his landlady (the translucent sketch of her amorphous presence dwelt over in shimmering sensuous trivia by Gunn's imagery), and the faded implications of the hazy harmless prattle they trade at his Richmond lodging house. Beyond these blurry intangible encounters the narrative (at least the narrative of Evan and *Caroline*) fails to proceed. Nothing happens or ignites. There are zero plot points, Emily the 'amanuensis' frets, for 'turning and thickening'.

Her plan had been to 'construct a meticulous record ... which would comprise a lively and involving narrative based upon two people who had met by chance and were now, in the manner of protagonists in some early Renaissance or medieval text, deeply in love'—but holed up with Evan evening after gin-dazed evening to decipher the 'key facts' around which she can engineer an 'onward moving narrative', Emily finds her text 'caught in the perpetual present tense' of Evan's stalled and ineffectual passion. Her novel is void of events. And as a writer—albeit the author of only a handful of published short fictions who finds herself largely penning advertising copy, lauding ludicrous concoctions of high-class dog cuisine to 'pampered pets'—Emily knows that readers 'like resolution, conflict, drama ... Novels want more!' Her work scripting Evan's sad secret rapture cannot sustain itself by endlessly revisiting the few bits of luminous but inconsequential detail he provides for her.

The need for 'shape and narrative momentum' is continually raised by the harassed Emily as she meets her protagonist in pub after seedy-posh pub, as is 'relevance to the general reader' and the need for a novel to have 'substance and ballast'. 'Less introspection more action,' Emily presses him, losing patience with his lovelorn dissolution, and the way the pace and propulsion of his narrative seems to be 'wasting away' along with his shockingly altered work ethic and appearance. Even the love interest, the artlessly luscious Caroline, around whom the unformed novel swirls—Caroline of the unconsciously sexy gestures alone in her stale marital home, a privileged blonde of unthinking bewitchment from a world where people stay together for the polo ponies—ultimately seems to represent a textual emptiness, an absent locus of vacuous longing that catalyses nothing and will never be quenched: 'all feelings emptied into Caroline as though she contained them all ... Down, down into Caroline had gone all our selves, all our dreams and hopes and will, imagination ...'

Yet even as Gunn's distressed narrator is cataloguing fiction's needs for 'actual chapters with activities crammed within them that might move a story along', she is simultaneously delivering a masterclass in eloquently messing with the mainstream demands of the novel. Because the heroine's rising lamentations about the chaotic state of her 'narrative arc' are shot through with striking highlights and insights from

Gunn's overarching experiment—which is, of course, precisely to defuse and diffuse the novel's normative conventions. For if love is a radiant derangement that stretches time, provokes anticipation, entrances moments, paralyses direction, seduces meanings and ultimately shakes life out of its established frame, why should a love story not do the same to narrative? Emily's lovesick text is a stressed one, rippling with intricacies bidden by feeling, diverting down paths pulled by hotblooded subtext, looping around her own sequence of love-stilled moments, points in her dialogue with Evan which quiver with her suppressed longing for him—even as she upbraids him for the way his lapsed and dislocated story falls likewise prey to love.

Everywhere there are signs of Gunn enjoying this play with her rapt characters and their fractured narratives—signs too of her teasing and enticing the reader with her novel's self-reflexive play, delighting in the way the story, like its lovers, gets lost and comes undone. Emily may be driven to distraction by her novel's love-struck lack of 'condition', but through her Gunn sets about cleverly steering 'a process towards a story that would happen in such a strange invisible way that many people might think that nothing much was even happening at all', *Caroline's Bikini* becoming a tissue of luminous alternatives to narrative drive. Knowingly pushing the reader's taste for 'some kind of action, drama', it instead lingers on and elongates moments, illuminating Gunn's craft of 'building a picture', 'texture gathering', 'layering, layering', circling always the 'detail, detail' that might create 'a pulse in the text'.

It's a counter-narrative technique that glitters with Gunn's sheer genius, and links her to Mansfield and Woolf (both of whom the novel slyly mentions), marking 'a way of reading fiction that is constructed of individual moments, rather than some big story, a row of lamps ...' That Woolfian net of subtly glowing moments is beautifully achieved here, the 'separate scenes all building up, accruing'. It's sustained by an equal delight and exquisite skill in evoking the narrative voice: Emily as heroine emits a nervy brightness that's redolent of Woolf and Mansfield too, a 'migrainey' lightness through which the reader senses undercurrents of strain. The brittle tint of studied giddiness that inhabits her voice has an uptight effervescence, a cultivated 'bright smile' that feels too tight-wound, and feeds us clever cues to the pain underpinning her pitch of diverting frivolity. (There's a parallel with Caroline, who also seems bent on dressing up the absence at the core of her life with the outward trimmings, and prescription uppers, of a relentlessly 'fun scene'.)

As Emily's voice gives Gunn endless scope for skirting and spilling subtextual details, it also displays the magnificent fluidity and flexion of her sentences at full range—the poise, the beat, the pull, delay, the delicate stresses and drifting

weight of her sentences are nothing short of spellbinding. The story moves with a 'lovely unspooling' that, for all the book's astonishing cleverness, never allows it to feel like a postmodern game. Indeed, 'games' in this novel come to resonate with a vastly more emotional meaning, their play sending roots into the childhood past that binds Evan and Emily, and which Gunn uses to structure the 'Ready/Steady/Go' of her novel's sections, evoking a tender portrait of the ties arising from a shared long ago.

Gunn's delicious deconstructive meddling continues until the novel's close with an outcome that defies Emily's claim that 'endings … are for weaklings'. In a novel that has tampered endlessly with readerly expectations, flirting its way around its 'finishing lines', it's delivered with an immensely appetising twist. The invitation to the closing pool party—whose promising 'tidings' of chlorinated blue have titillated and evaporated throughout the story—is funnily fulfilled, bikini included, after stringing the reader along with cultured peekaboo. Emily might flush at the 'corny' lovelorn tropes her project forces her to indulge in—'like a scene in bloody *Middlemarch*'—but *Caroline's Bikini* closes with a scene that is at once a final cocktail of inspired deconstructive coquetry and a brazen heart-racing return to the pleasures of the page provided by an Eliot or an Austen. It's a masterstroke (like the rest of this novel) of moving charm and sharp contemporary guile, Aristotle spiked

with arch chick-lit, with an acid sliver of a postmodern gesture on the side. Drink it in. Like all Gunn's earlier novels, *Caroline's Bikini* left me longing to join her at a nearby bar for a writerly chat over a shameless number of gins.

A Kind of Masterwork
by Philip Temple

Charles Brasch Journals 1958–1973,
selected and with an introduction and notes
by Peter Simpson (Otago University Press,
2018), 694pp, $60

Three-decker novels and journals were
the acme of literary endeavour in
Victorian England. Anything resembling
this in New Zealand has been absent
until this year when volume three of
Charles Brasch's journals appeared. To
resurrect the genuine meaning of a now
much-abused word, this publishing
event is unique in New Zealand literature;
and any review of volume three, covering
the years from 1958 until Brasch's death
in 1973, must be necessarily also an
overview of the entire project.

Some facts and figures first. The three
volumes add up to more than 2000
pages. The first volume published the
journals from 1938 to 1945, verbatim
from the transcriptions of Margaret
Scott, and included an introductory essay
by Rachel Barrowman. Scott was a close
friend of Brasch and, briefly, even his
lover in the early 1960s. Following Scott's
illness and then death in 2014, the
project was taken over by Peter Simpson,
who completed work on volume two
(1945–1957) in 2017; and this final
volume in 2018.

Apart from Margaret Scott as
transcriber, the others behind the

production of all three volumes have been
Brasch's literary executor, Alan Roddick,
and Otago University Press publisher
Rachel Scott—Margaret Scott's
daughter—and her team. Additionally,
there have been invaluable contributors
to the appendices, such as Andrew
Parsloe for the 'Dramatis personae'. Each
volume also includes a chronology and
family tree; volume two has a 16-page
insert of photographs; volume three,
eight pages. The only blemish is the lack
of an index for volume one. Nevertheless,
literary and publishing masters in their
fields have achieved a monumental result
over the 15 years since Charles Brasch's
papers were released from their 30-year
embargo.

Peter Simpson wrote extended
introductions to volumes two and three.
In volume two he recorded that the total
number of words for the period covered
amounted to about 325,000, 'roughly the
same as George Eliot's *Middlemarch* or
Tolstoy's *Anna Karenina*'. He faced the
task of cutting the journals down to a
publishable length of about 180,000. This
demanded not only excellent sub-editing
skills but also an expert eye for both
Brasch's most memorable writing and
the narrative strands that bind together
the story of a life and its work. Although
he does not say, Simpson presumably
faced a similar task for volume three.

Volume one's journals covered the time
when Charles Brasch was in England just
before and during World War II until he
returned to New Zealand. After the better

part of 17 years in Europe, he was 'resolved to go & to stay, or try to, & start the periodical which is now much in my mind'. The periodical in question was *Landfall*, which he established in 1947, and which became the journal of literary and cultural record in New Zealand. Brasch was to become the chief benefactor of arts fellowships at the University of Otago and a major donor of art works and other materials to the Hocken Collections and Otago Museum. By the time of his death in 1973 Brasch had also confirmed his status as a significant New Zealand poet.

The journals published in volume two largely followed four strands expressed in Simpson's introduction: the family; the personal; the cultural; and the mountains, especially of Central Otago. The volume was notable for its revelation, long obscured, of Brasch's homosexuality and his passion for Harry Scott, dashed by Scott's marriage to Margaret Bennett. Volume three is more focused on the cultural and personal. We read of the devastation wrought on Brasch and Margaret Scott by Harry Scott's death in a 2000ft fall from the summit ice cap of Aoraki Mount Cook in February 1960. Three weeks afterwards, 'She cannot believe that he is dead. I can only half believe it; I keep having fantasies that he was somehow preserved, & will walk in again any day. The shock of his falling grows stronger in her; she thinks of what a shock it must have been to him as he realized it' (24 February 1960).

Eighteen months later Brasch had his brief affair with Margaret Scott, which she later claimed was also his first sexual experience. Brasch told Scott that 'different kinds of love may exist at the same time', but later she told him he 'behaved towards her, she sees now, as if she was a man' (4 September 1961). Brasch's real focus of passion after the death of Harry Scott was English marine biologist Andrew Packard, whom he first met when Packard was managing the Portobello marine research facility in 1958. But in his passions for both Harry Scott and Andrew Packard, Brasch was fixating upon almost perfect, even god-like, heterosexual figures that would remain beyond reach. He always considered the male physique more beautiful than the female. On seeing Packard, Brasch 'was struck more forcibly than ever by the extraordinary beauty of his face & expression'. At night he woke 'with such a terrible longing to see him again, fearing that he will soon go away forever' (14 October 1958). Brasch met up with Packard again in England and Italy but his feelings were never requited. Although he had homosexual relationships later in life, they were anonymous—some sections of his journals were excised to ensure they remained so. None of his grand passions were fulfilled.

Peter Simpson devotes the first section of his volume three introduction to Brasch's personal life before moving on to 'Other friends, artists and writers', which were legion, often related directly

to the inclusion of their work in *Landfall*. He continued to edit the quarterly until the end of 1966; 20 years of extraordinary devotion to the cause of developing a civilised life in New Zealand. The journals are full of comments about writers and artists of the period, a rich lode to mine for fashioning an understanding of the development of New Zealand literature and art during the 30 years following World War II.

In commenting on a Lionel Trilling essay, Brasch remarked, 'Is N.Z. an *anti-civilization*? Hatred of the ordinary NZer for all distinction—of speech, carriage, dress, behaviour, mind; for refinement in general, for the arts, in a word for civilization itself. Then, besides that, the element of revolt against civilization by its very creators: this is clear in the work of Fairburn Glover Baxter & in the life of each' (28 January 1962). But if Brasch considered that most New Zealanders belonged to an anti-intellectual 'petit bourgeoisie', there was the weighting compensation for him of the land itself. At the end of volume two we read of it as 'richly various, with much packed into little, with grandeur and great distances, more than enough to enjoy for a lifetime, large enough for a people and a civilization' (30 December 1957). In volume three, soon after his 'anti-civilization' entry, we read of 'the noblest scene in NZ' from Paradise and up the Dart Valley. In describing the mountains, he writes, 'I love them all, their splendid proportions, their space

& vastness & sheerness, brilliant beauty & danger & savage indifference & monotony & vulnerability ...' (7 February 1962).

Alongside this rapture over landscape runs Brasch's poetry: his reflections, his experiments, his satisfactions and successes. Even to the end. When he came home to die of Hodgkins lymphoma in May 1973, aged only 63, Margaret Scott visited him and brought him, out of season, a bunch of his favourite flowers: anemones. They inspired one of his last and most memorable poems, 'Winter Anemones', which ends, 'See, they come now / To lamp me through the inscrutable dusk / And down the catacombs of death'.

During his final illness, poet Fleur Adcock wrote to Brasch. She told Margaret Scott she had expressed her 'personal gratitude for his kindness over the years', articulating 'how much he had done for us, and how important he had been in our lives'. After he died, Scott wrote to Adcock saying that when she had also said she would like to write a poem to him, he had broken down and cried. Scott told Brasch that 'when you are ill people know that they have a right to say how they really feel. And you know now, don't you, how much loved you are' (p.87).

There is certainly an element of love for a man who devoted so much of his life—and money—to securing the growth of a 'civilized' New Zealand from the family, friends and scholars who have created in these three volumes a kind of masterwork.

Infectious Curiosity
by Lynley Edmeades

louder by Kerrin P. Sharpe (Victoria University Press, 2018), $25; **Enclosures 4** by Bill Direen (W. Direen, 2018), 82pp, $20; **Luxembourg** by Stephen Oliver (Greywacke Press, 2018), 112pp, $24.95

louder is Kerrin P. Sharpe's fourth book in six years. Knowing this publication background, I was somewhat sceptical at the outset, I must admit—what can a poet possibly find to write about in such quantity? In this era of information overload it is easy to be dubious of those who keep on saying, saying more or saying louder, as the case may be. However, my dubiety was swiftly allayed as I entered the world of Sharpe's new book: I was promptly reminded of the joys of reading the work of a skilled craftswoman who, while she is aware of tradition, is not afraid to take some risks, in both form and content.

From the outset, the collection draws the reader in to its subject matter with a certain level of mystique and experimentation: the first poem comes in the form of a Venn diagram, which seems to outline some of the themes that appear throughout the book. In the middle of these two overlapping orbs is the word 'louder', which then becomes the title poem. This poem is great but the following poem, 'when the barber talks about elephants', is exceptional. Like the title poem, it also uses jungle giants to illustrate some of the contemporary transgressions Sharpe is committed to exposing:

> a nursing elephant in West Bengal
> is shot as she drinks
> from a river
> and her baby feeds until
> her mother freezes under the Indian sun

What strikes about this and many other poems in the collection is the way Sharpe manages to deal with large subject matter with such a pared-back, quiet empathy. While there are a couple of occasions in which the treatment of big issues is just a little too obvious, at no point are these poems didactic or polemic; instead, it is clear how deeply the writer cares for the issues she has chosen to write about, topics such as refugee policies, environmental degradation, moral injustices. These poems are not interested in telling the reader how much we've fucked the world (and our country). Rather, they want to say why we should care. From 'smoke and hair':

> on Ching Ming Day
> she cycles through Shengfang smog
> and the forests of buildings
> to her mother's grave
> even her fishing lamp stutters
> ...
> she wipes the headstone
> her handkerchief blackened
> like her mother's name
> like the darkness where her mother
> grew a teratoma
> the cyst filled with smoke and hair
> she hoped would be a sister
> at the crematorium
> her mother became industrial
> and didn't recognise her

Like this poem, much of Sharpe's book is distilled, deceptively simple, and beautifully realised. This collection stands as an elegant protest against the rise of the personal-confessional lyric we see everywhere in contemporary poetry, whereby poets often confuse the *personal is political* message with the idea that writing about the self is, in and of itself, a political act. Sharpe has turned her eye to the real politic here. And yet, although these topics are hard to come by in contemporary New Zealand poetry—or when they are, are often treated with a cringe-worthy heavy hand—this collection offers a powerful, timely and, overall, empathetic meditation. Controlled, expertly ordered and refreshingly engaged in the real world, Sharpe's new collection is, as the publishers correctly posit on the back of the book, arresting.

Enclosures 4 is the fourth and final in a series that Bill Direen has been at work on since 2008. These books are, for want of a better word, miscellanies. Small, almost pocket-sized anthologies, the four *Enclosures* are rich in eccentricities and experiments. This final edition includes, says Direen himself, 'a folk tale, a creative essay, a plan for a theatre in mourning, mathematical despair, some thoughts on drainage in the Netherlands (and Breughal), lyrics from recent text-music recordings ... and the last instalments of the fragmentary novel about Dunedin denizen Robert Stoat'.

The book starts with 'Tyrant Dream Story'. Described as a folk tale, it takes the reader on a whimsical Ancient Mariner-esque journey of sage-like story telling. The scene is set with both the oneiric title and an epigram by Lisa Samuels, another fine experimental writer so often ignored by the nation's poetry pundits. The story is indeed dreamy—slippery and strange, it performs what Samuel's quote describes as 'idea's blast-off premonition'. It is about a tyrant and his daughter's wedding, but it's also about potatoes and gold and dreams and alchemy. It sets the scene for the diversions and inversions that follow.

And what follows is a gala of ideas, language play, performativity, comments about voice and speech and storytelling, at the very least. Many of the pieces have epigrams, and this panoply of other voices that Direen hangs out with here includes the aforementioned Samuels, Erasmus, Antonin Artaud, the great Northern Irish poet Ciaran Carson, director Francis Hervé, Harry Matthews (on Perec, no less) and a Facebook friend of Direen's, Richard Taylor. This truly democratic gathering is, it seems, illustrative of both the sources that Direen draws from and the ways in which he engages with written and performed work: nothing is out of bounds.

Most readers will know Direen as a musician. But if you've ever seen him perform, you'll know that he's much more than that, as this book illustrates. A wonderful performer of both his music and his written work, he displays a level

of attention to the sonic here and elsewhere that comes from his musical and theatrical background, and gives his work its performative quality. From the beginning of 'Manima & Minima', a 'love story', we're told:

> The mouth is making unwanted sounds as it makes the words we instruct our mouth to make. It has always been this way. They are the sounds we expunge from voice recordings if we can, breaths and tonguings that are too intimate for audio-biological sounds happening around about our word sounds. They belong to your voice and mine.

Much of this collection is 'breaths' and 'tonguings' (what a verb!), and here is much to feast on, or to slip on. As Direen says in 'G', a 'mathematic desperation': 'The time of knowing anything had ended.' This feels like the key to this latest book, and potentially Direen's whole oeuvre. His work takes you towards an unknown, unchartered place, resisting categorisation completely—it just plays, but with an infectious curiosity and pleasure. In the age of the popular poet, Direen should be lauded: he's not interested in shocking or even being noticed. Rather, he is quietly going about his literary business, authentically interested in reading and writing, in language and ideas. If there is such a thing as an avant-garde in Aotearoa poetics, Direen is at its non-centre.

An altogether different beast from Direen's, Stephen Oliver's new book announces his return to New Zealand after twenty years in Australia. While Oliver has maintained a presence in New Zealand literature in those two decades, this book draws on the poet's permanent return to these lands, allowing that peculiar defamiliarisation to drive the collection.

This making-strange forms something of the backbone of *Luxembourg*, and lets Oliver make some sharp comments about the New Zealand that he's come home to: a bloated dairy industry, slovenly small-town commerce, the culture–landscape enmeshment that continues to dominate. Oliver captures it beautifully at times, invoking the imagist tradition with great aplomb. Here are some excerpts from a long, multi-faceted poem called 'Road Notes':

> Dragged-down hills and pocket-cleft bush over the Waikato River moving with chain mail sluggishness.
>
> High beam hauls in the white line; the Milky Way, its skid marks slung across the sky, runs out of steam.
>
> Tyre screech. Magpie warble. Morepork's soft call. Town lights come on, slow yellow, hum of fridge door left open. Dusk.

It is difficult to be selective of excerpts to illustrate Oliver's class; there are so many brilliantly rich lines like these that conjure up something of that rural, semi-industrial, slightly melancholic New Zealand. This is Oliver at his best— crystalline, alert, evocative.

While this collection teems with riches of this kind, it is baggy with other issues. This first of these is the book's

length; at 96 pages, there is a lot of wading-through required of the reader. There are some poems that do particular things very well; there are others that attempt to do the same but lack the refinement of distillation of their superiors. In saying that, the stand-outs are worth hunting out—perhaps all the better for being surrounding by their lesser cousins. This could have easily been ironed out with some thorough editing.

The second issue is not as easily talked about, but necessitates comment for that very reason: the male gaze. Try as I might to ignore it—even after the opening poem portrays 'desiccated, middle-aged matriarchs' who are 'unravelling, winding sheets / of dry sexual longing'—as the collection goes on, this noise gets louder and louder. It comes in various tones, or shapes, as the case may be. In one instance our country's greatest female writer, or the image of her, becomes a synonym for frumpy middle-aged women: 'This is rural New / Zealand, where every woman over forty / looks like Janet Frame in a parallel universe, / of the underprivileged' (in 'Undercover'). On another occasion the poet imagines Rupert Brooke as partaking in such indulgent gazes too: 'The country was troubled by strikes and he considered the women if not ugly certainly dowdy' (from 'Tracking Rupert Brooke'). Even some of the great moments of this book are tainted by it, where the poet's gaze is simultaneously delightful and

abhorrently misogynistic. From 'Green Asterisk':

> The wives lack a
> city, money gives them privilege, protection,
> which clears
> a space around them, empty ownership of air.
> A cabbage tree
> pins its green asterisk to the ridgeline.

The cabbage tree as green asterisk is undeniably brilliant, but is hard to stomach it when it follows 'the wives', just some of the women in this collection who are nothing more than 'desiccated', wanton 'dusky maidens' (yes, that is a quote). And while there are some women who are granted agency throughout *Luxembourg*—with quotations penned or dedications in their name—the stage is already set; these presences only drew attention to themselves, and seemed, at the very least, perfunctory inclusions.

I don't think Oliver is solely to blame here: this misogyny is part of what I can only hope is a dying tradition in both New Zealand and international Anglophone poetry. The truth is that men simply can't write about women any more without very, very careful consideration. This lack of careful consideration seems strange to me, as it goes against many of Oliver's strengths, so considered is he of so much else.

The Kete of Bounty and the Cross-tide of Loss

by Arihia Latham

Tāngata Ngāi Tahu/ People of Ngāi Tahu
(Vol. 1), eds Helen Brown and Takerai Norton
(Te Rūnanga o Ngāi Tahu/ Bridget Williams
Books, 2017), 352pp, $40

Opening this book is like stepping into a wharenui with pictures of revered tūpuna on the walls. At first it is the beautiful pictures that capture your attention—the arresting portraits of each tangata toa. Yet it is the stories behind their eyes, the intricacies of each of their lives, that fill you with warmth, awe and deeper understanding. The stories in this book cover a 200-year period that saw much turmoil for the iwi. Instrumental people worked tirelessly for the iwi in moving toward Te Kēreme—the claim that was first taken to the courts in 1868, whereupon the government made it illegal for the courts to hear it. It wasn't until 1997 that the Ngāi Tahu deed of settlement was finally signed, and the Ngāi Tahu Claim Settlement Act was passed in 1998. This book, a joint publication between the Ngāi Tahu archive team and Bridget Williams Books, coincides with the twentieth anniversary of this longstanding mahi of our tūpuna. In 2018 it won the non-fiction prize in the New Zealand Heritage Book & Writing Awards.

An emotive response is inevitable in reading such personal stories of trial and triumph. As a Ngāi Tahu descendant I find myself wondering, as I know many others would if they knew my great tāua, about the times of many of the tāua and pōua in these pages. The interviews with the whānau of those featured were carried out throughout Aotearoa 'from Awarua to Rotorua and over many cups of tea'; emails and phone calls spanned the world. What we can't see in these pages is all the laughter and tears the memories no doubt brought up, but we can certainly feel them. We must also acknowledge all the blank spaces in these pages of those tīpuna who have passed, and those whose descendants know little more than their name, whose stories are now lost to the wind.

This is by no means a complete book of all of our whānau stories—it is but an extraordinary beginning. Regardless of one's heritage, the book is a fascinating window into our country's history. The stories of the immigration of settlers here and the early relationships formed are things we all can relate to and reflect on.

One thing that is refreshing is the gender balance achieved in the book. Many wāhine are celebrated here for their contribution to the marae, iwi, Te Kēreme and also their families, the arts, education and women's rights. 'We had a commitment to have as many female voices as possible, this was not just the great men of Ngāi Tahu, it's not just the people who made up delegations to

parliament ... but the little nails that held the tribe together at the village level as well,' says University of Otago senior lecturer in Māori history Michael Stevens, one of the contributors.

We can read about Raukura Erana Gillies, acknowledged as 'a profound source of customary knowledge' as well as a skilled weaver and midwife. My ears pricked up reading about Mere Harper, a surname in my own whakapapa, and her incredible strength. Known as 'Big Mary' because she was so tall, she earned money as a young woman carrying passengers ashore on her back. Her character is evident in this excerpt: 'anyone taking liberties with the lady in her task of porterage soon found a sudden bath'!

Some of the details of these stories are heart wrenching, coming as they do from both the kete of bounty and the cross-tide of loss that is every life lived. Reading this book was like peeling spuds in the wharekai and listening in on who was with who and what illegitimate child had turned up or who had survived their siblings or only children. The detail of the peaks and troughs in each story is an invitation to be part of each personal celebration or grief.

The story of Amiria Puhirere Hokianga, known as the 'the mother of the Māori people', struck me particularly. She was known for swimming three kilometres across Akaroa Harbour to attend meetings and tangi and to assist with births. She was considered an expert in language, customs, history and weaving. She also lost six of her nine biological children, going on to adopt and raise many others.

Kelvin (Kelly) Anglem, who was known as the first kaiwhakahaere of Te Runanganui o Tahu in 1990, married his love Margaret and became a parent to her four children as well as fathering their own daughter. Kelly was also a great advocate for environmental protection, particularly our precious awa and waterways. He lamented: 'I am glad my tupuna cannot stand on the banks of the Opihi and see what I have stood back and allowed to happen.' On reading that I couldn't help feeling the exact same sentiment. The mahi must continue, and if that is the result of this book—to stoke the fires of ahikā in people to keep alive the work started by these hardworking people—then that is a triumph in itself.

These intricacies of character, empathy, strength and moral fibre are what change a story of someone's achievements on paper to something warm, almost palpable, like holding the hand of a kaumatua, their tissue-paper skin, veins protruding like tributaries of their awa, shaking slightly in your grip.

Hoani Tamahika Matiu was the only one of eight siblings to survive to adulthood. He also lost his own three children. Yet despite this tragedy, or perhaps because of it, he became one of the iwi's most respected historians. Described as an 'encyclopedia of Māori lore and history', he would use small stones in his pockets to remember historical deeds of tūpuna. He would also

recite the words of ancient waiata to prove points in historical debates. Details like these are the taonga of this book.

It is a treasure trove of Ngāi Tahu tikanga. Ulva Belshem shares the challenges and joy of learning about collecting tītī: 'What a privilege our old people have given to us—to enable us years later to succeed them to be able to go to those islands where they argued and talked for days (and nights) and established their right to go and take tītī each season.'

Wiremu Solomon was named the takata kaitiaki of Kāti Kuri, as he held so much knowledge for all of the tūpuna buried there. He travelled past constantly in his time working for the railways, and went on to serve on the Ngāi Tahu Māori trust board for twenty years. Kath Brown was a tohunga raranga, a master weaver who led teams of weavers in the production of decorative works for many marae.

The stories of Doug Sinclair, the tenth Māori doctor to qualify in Aotearoa, and Maria Tini, a strong leader for Murihiku, tell of their mahi and love for Ngāi Tahu despite living in Ūawa (Tolaga Bay) and Rotorua respectively. Erihapeti Rehu-Murchie travelled to the United States and Fiji as a Human Rights Commissioner and advocate to the minister of Māori affairs; and Eva Skerrett, 'the Māori Nightingale, lived and sang in England upholding the mana of their iwi abroad'. For many Ngāi Tahu spread around the world this reminder of the strength of that iho (umbilical cord)

to our turangawaewae is omnipresent.

While there are too many important stories to do justice to here, I think the key thing about this book is that from its pages anyone can learn about the strength of character, our unique taonga and tikanga and of the ongoing and real struggle for Ngāi Tahu people. Through these stories we can very nearly see that the breath of the kaumatua profiled here have fogged the glass of time.

Victoria University Press
new titles 2019

May, p/b, $40

May, p/b, $40

March, p/b, $25

March, p/b, $30

future Landfall editor swots up

Contemporary New Zealand Fine Art

Weekdays 9 am - 5 pm / Saturdays 11 am - 3 pm
Queen's Birthday Monday 11 am - 3 pm

Milford Galleries Dunedin

www.milfordgalleries.co.nz

18 Dowling Street, Dunedin 9016 | Ph (03) 477 7727 | info@milfordhouse.co.nz

You've read the book, now try to read the writer.

ŌTEPOTI – HE PUNA AUAHA
DUNEDIN UNESCO
CITY OF LITERATURE

NEW BOOKS FROM

OTAGO

WEST ISLAND:
FIVE TWENTIETH-CENTURY NEW ZEALANDERS IN AUSTRALIA

STEPHANIE JOHNSON

Five notable twentieth-century New Zealanders who made their lives in Australia are the subject of this fascinating biographical investigation. Part biography, part memoir, this is an exploration of the cultural divide between Australia and New Zealand by an award-winning author.

ISBN 978-1-98-853157-1, paperback, $39.95

DEAD LETTERS: CENSORSHIP AND SUBVERSION IN NEW ZEALAND 1914–1920

JARED DAVIDSON

In 1918, from deep within the West Coast bush, a miner on the run from the military wrote a letter to his sweetheart. Two months later he was in jail. Like millions of others, his letter had been steamed open by a team of censors. Using their confiscated mail as a starting point, the author reveals the remarkable stories of people caught in the web of wartime surveillance.

ISBN 978-1-98-853152-6, paperback, $35

TO THE OCCUPANT

EMMA NEALE

A strong new poetry collection from a leading NZ writer of her generation takes the everyday and transforms it into something fine, precious and enduring. With an unsparing attention, these shape-shifting poems confound prejudices and subvert expectations. This is poetry filled with musicality and dynamic language, always observant to the world and its details.

ISBN 978-1-98-853168-7, paperback, $27.95

EVERY MORNING, SO FAR, I'M ALIVE: A MEMOIR

WENDY PARKINS

Beautifully written, intensely moving and threaded with self-deprecating humour, this memoir is about claiming the right to tell our own story and learning to embrace the risks that the messy unpredictability of life always entails. It charts the author's breakdown after migrating from New Zealand to England: what begins as homesickness and career burn-out develops into depression, contamination phobia and OCD.

ISBN 978-1-98-853161-8, hardback, $35

Otago University Press
From good booksellers or www.otago.ac.nz/press

CONTRIBUTORS

John Adams is an Auckland poet. His first collection *Briefcase* (Auckland University Press, 2011) won the Jessie Mackay Award for best first poetry book. His second collection is *Rumpelstiltskin Blues* (Steele Roberts, 2017).

Peter Bland's latest collections are *Voodoo* and *The Happy Garden: Selected poems for children* (Steele Roberts, 2018). His collection of poems about paintings, *Just Looking*, will be published in 2019 by Cuba Press.

Laura Borrowdale is a writer and teacher from Ōtautahi, Aotearoa. Her work has appeared in *Turbine|Kapohau*, *Sport* and a number of other journals, and she is the founding editor of *Aotearotica*.

Bill Bradford lives in the far north. He has worked as a trade union organiser, a shepherd and a labourer, but now spends his time gardening, fishing, writing and drinking cider.

Iain Britton has published five collections since 2008, mainly in the UK. The latest, *The Intaglio Poems*, was published by Hesterglock Press (2017). His work has also appeared in *Landfall*, *Brief*, *Poetry New Zealand Yearbook*, *Cordite*, *Southerly Journal*, *Meanjin*, *Harvard Review*, *Poetry* (Chicago), the *New York Times*, *Jacket2*, *Stand*, *Poetry Wales*, *Agenda* and the *Journal of Poetics Research*.

Medb Charleton was born in Sligo, Ireland, and divides her year between there and Raglan, New Zealand. She has had poems previously published in *Sport*, *Poetry New Zealand*, *Landfall*, *Turbine|Kapohau* and *Snorkel*.

Stephen Coates comes from Christchurch and is living in Japan. His stories have been published in *Landfall*, *takahē*, *Headland* and *So It Goes*.

Carolyn DeCarlo lives in Wellington with her partner Jackson, and one very important boycat, Jareth. She has written several poetry chapbooks. She is the co-creator of the Wellington-based reading collective Food Court.

John Dennison is the author of *Seamus Heaney and the Adequacy of Poetry* (Oxford University Press, 2015), and *Otherwise* (Carcanet and Auckland University Press, 2015), a collection of poems that was long-listed for the 2016 Ockham NZ Book Awards and short-listed for the Seamus Heaney Centre for Poetry Prize for Best First Collection, 2016. John was recipient of the 2016–17 Creative New Zealand Louis Johnson New Writer's Bursary. He lives with his family in Tawa, Wellington.

Lynley Edmeades is the author of *As the Verb Tenses* (Otago University Press, 2016). Her second book of poems is forthcoming in 2020. She currently lectures in the English programme at the University of Otago.

David Eggleton lives in Ōtepoti/Dunedin, where he is a poet, writer, reviewer and editor. His most recent collection, *Edgeland and other poems*, was published by Otago University Press in 2018.

Joan Fleming is the author of *The Same as Yes* and *Failed Love Poems* (both with Victoria University Press). Her third book is forthcoming with Cordite Books.

Jasmine Gallagher has published numerous poems in the experimental journal *brief* (previously under her nom de plume 'Berengaria Burns'). She is a doctoral candidate at the University of Otago where she is researching the dialectics of 'Antipodean Gothic' and 'New Sincerity' in contemporary New Zealand art and poetry.

John Gallas is a New Zealand poet. He has had 18 collections published, mostly with Carcanet. He currently lives in Markfield, Leicestershire, but returns home each year and heads for Kahurangi National Park.

Brett Gartrell lives and works in the Manawatū, caring for small broken things. He wrote this poem as part of the Masters of Creative Writing degree at Massey University.

John Geraets was the editor of the recent special issue of the *Journal of New Zealand Literature* on innovative writing, and a selection of his writing, *Everything is Something in Place*, is due to appear shortly from Titus Press.

Tim Grgec has a master's in creative writing and English literature from Victoria University of Wellington. He was the poetry editor of last year's Turbine|Kapohau, the literary journal of the IIML.

Michael Hall is a poet who lives in Dunedin.

Ngahuia Raima Harrison (Ngātiwai, Ngāpuhi) is a Tāmaki Makaurau-based artist. She is completing a doctorate at Elam School of Fine Arts. Her research investigates the impacts of the Marine and Coastal Area (Takutai Moana) Act 2011 upon Northland hapū. Through photographic and video works Harrison wants to record this legislation's impact on tribal groups whose identity and sustenance are derived from the sea and coast.

Rebecca Hawkes is a painter, cryptid and reluctant corporate ladder ascender. You can find more of her writing in *Starling*, *Sport*, *Sweet Mammalian*, *Mayhem* and elsewhere via www.rebeccahawkesart.com.

Joy Holley is from Wellington and has recently completed her bachelor of arts at Victoria University. Her writing has also appeared in Turbine|Kapohau, Starling, The Spinoff, *Mayhem*, *brief*, *kiss me hardy* and Headland.

Aaron Horrell was a small-town bogan but is now a soulless bureaucrat. His work has appeared in Kiwi journals like Headland, *Alluvia*, *takahē*, Turbine|Kapohau and *Landfall*. He is a staunch unionist and is almost certainly a narcissist.

Michael Hulse is a poet and translator, and a professor of poetry and comparative literature at the University of Warwick. His account of days in Venice with Allen and Jenny Curnow in 1988 appeared in *Landfall* 222.

Gail Ingram's poetry and short stories have appeared in numerous publications, including *Poetry New Zealand*, *Atlanta Review*, *Blue Five Notebook*, *Cordite Poetry Review* and *Manifesto*. Her first book *Contents Under Pressure* includes two award-winning poems and will be published by Pūkeko Publications in 2019. She is a poetry editor

for *takahē* and a fiction editor for *Flash Frontier*.

Claudia Jardine is a poet and musician based in Pōneke. Her work has appeared in *Starling, Salient, Salty, Mimicry #2* and *The Spinoff*. In 2019 Claudia began a master's in classics at Victoria University Wellington and will release her first EP.

Sam Keenan lives in Wellington. Her work has appeared in *Cordite, Landfall* and the *Poetry New Zealand Yearbook*. She was runner-up in the 2017 *Sunday Star Times* Short Story Competition.

Erik Kennedy is the author of *Twenty-Six Factitions* (Cold Hub Press, 2017) and *There's No Place Like the Internet in Springtime* (VUP, 2018). He is the poetry editor for Queen Mob's Teahouse. He lives in Christchurch.

Arihia Latham is a writer and facilitator in Wellington, where she lives with her partner and three children. She is Ngāi Tahu Māori, Dutch, English and Irish. Her work has been published in two Huia short fiction collections and she received an award for the novel extract 'Ahikā'. Her story 'Fly Away Home' has been broadcast on RNZ, and her poetry has been part of Matariki and LitCrawl. In 2018 she read her work at the Adam Art Gallery.

Jessica Le Bas has published two collections of poetry, *incognito* and *Walking to Africa* (Auckland University Press, 2007/2009), and a novel for children titled *Staying Home* (Penguin, 2010). She currently lives and works in the Cook Islands.

Wes Lee lives in Wellington. Her writing has recently appeared in *The Stinging Fly,*

Turbine|Kapohau, New Writing Scotland, Westerly, The London Reader, Poetry New Zealand and *takahē*. She has won a number of awards for her writing and was a finalist for the Sarah Broom Poetry Prize 2018.

Tina Makereti is the author of *The Imaginary Lives of James Pōneke* (Vintage, 2018) and *Where the Rēkohu Bone Sings* (Vintage, 2014). She is working on a collection of personal essays titled *This Compulsion in Us.*

Ria Masae is a senior librarian for Auckland Libraries. Her work has appeared in various publications, including the 2017 *Best New Zealand Poems* anthology, and the 2019 *Poetry New Zealand Yearbook*. She is currently working on a poetry collection for publication.

Cilla McQueen has published 15 collections, three of which have won the New Zealand Book Award for Poetry. Her most recent work is *Poeta: Selected and new poems* (Otago University Press, 2018). Other titles from Otago University Press are *In a Slant Light, Markings, Axis, Soundings, Fire-penny, The Radio Room* and *Edwin's Egg*. Cilla was the New Zealand National Library Poet Laureate 2009–11. In 2010 she received the Prime Minister's Award for Literary Achievement in Poetry. She lives and works in the southern port of Motupohue, Bluff.

Zoë Meager has a master's degree in creative writing from the University of Auckland, and her short stories have been published and commended at home and abroad. She is fiction editor for *takahē*.

Robynanne Milford is a retired general practitioner in Christchurch. In 2018 she published *Finding Voice: Women on the*

Dunstan, 1860–1900. Her previous publications include *Aspiring Light* (2015), *Grieve Hopefully* (2012) and *Songcatcher* (2009). Her poem 'Tidal Wave' was placed second in the 2010 Manuwatu International Poetry for Performance competition. Among other publications, her poetry has appeared in *The Unnecessary Invention of Punctuation* (2018), *Leaving the Red Zone*, *Voice Print 3*, *Canterbury Poets Collective* and *Crest to Crest*, and in *Landfall*, *takahē*, *Poetry New Zealand*, the *Press* and *Catalyst*.

Sean Monaghan was winner of the Sir Julius Vogel Award for Best Science Fiction Short Story, and has had stories in *Landfall*, *takahē* and numerous overseas publications. He lives in Palmerston North.

Art Nahill is an Auckland-based physician and poet. He prefers dogs to cats and is addicted to chocolate. His latest book *Murmurations* was born in 2018.

Kavita Nandan lives in Sydney but has her roots in the Pacific. She has an active four-year-old son and finds the short story to be a form she can work with. Recently her short stories were published in *Transnational Literature* (Australia), *The Island Review* (International) and *Landfall*.

Rachel O'Neill is a filmmaker, writer and artist based in Te Whanganui-ā-Tara, Aotearoa. Her debut book *One Human in Height* (Hue & Cry Press) was published in 2013. She received a 2018 Seed Grant (NZ Writers Guild/NZ Film Commission) to develop a feature film.

Maris O'Rourke is a walker and a writer, a poet and a peregrina. When she's not tramping/hiking/walking she likes to have

a number of writing projects on the go at once. Her memoir *Zigzags and Leapfrogs* was published by David Ling in 2019. Her first poetry collection was *Singing with Both Throats* (David Ling, 2013). Another poetry book, *Motherings*, is to be published in 2020, and a walking booklet *Finding Whaingaroa* is under way.

Claire Orchard's work has appeared in various print and online journals. Her first poetry collection, *Cold Water Cure*, was published by Victoria University Press in 2016.

Joanna Preston is a Tasmanaut poet and freelance creative writing tutor who lives in semi-rural Canterbury with a flock of chooks, an overgrown garden, and a Very Understanding Husband.

essa may ranapiri (takatāpui; they/them/theirs) is a poet from Kirikiriroa, Aotearoa. they have words in *Mayhem*, *Poetry New Zealand*, *Brief*, *Starling*, THEM, *Landfall* and POETRY *Magazine*. they will write until they're dead.

Anna Rankin is a writer and editor, and graduated with an MA from the IIML in 2018. She lives between Los Angeles and New Zealand and has published work for RNZ, *Brief*, Turbine|Kapohau, VICE, *Matters Arts Journal* and others. She has worked as an editorial assistant for Semiotext(e) and co-edits hard press.

Jeremy Roberts is a Napier resident and MC for Napier Live Poets. He interviews poets on Radio Kidnappers' Hawke's Bay Poetry Live show. His collection *Cards on the Table* was published by IP (Australia) in 2015, and his recordings with

international musicians can be heard on SoundCloud.

Leanne Radojkovich's début collection of stories, *First Fox*, was published in 2017 by The Emma Press. In 2018 she won the Graeme Lay Short Story Competition and was a finalist in the Anton Chekhov Prize for Very Short Fiction.

Carrie Rudzinski's work has featured in *Bustle*, *Huffington Post* and *Teen Vogue*, and she has performed her work in six countries and almost all of the 50 states in the US.

Kerrin P. Sharpe has published four collections of poetry, all with Victoria University Press: *three days in a wishing well* (2012); *there's a medical name for this* (2014); *rabbit rabbit* (2015) and *Louder* (August 2018).

Sarah Shirley is a junior doctor working in Hamilton. Her poetry has appeared or is forthcoming in *Landfall*, *takahē*, *Poetry New Zealand*, *Atlas*, the *Cider Press Review* and elsewhere.

Sharon Singer is a British-born New Zealand artist. Her figurative work has addressed the themes of narrative and meta-fictional awareness, feminist re-telling and fairy tale as popular culture. In more recent years her works invoke concerns such as the human condition in relationship to nature and metanarratives around global warming. Singer lives and works in Dunedin.

Tracey Slaughter is the author of the highly acclaimed short story collection *deleted scenes for lovers* (VUP, 2016). Her short fiction has received numerous awards, including the international Bridport Prize 2014, a 2007 NZ Book Month Award, and BNZ Katherine Mansfield Awards in 2004 and 2001. She

won the 2015 *Landfall* Essay Competition, and was the recipient of the 2010 Louis Johnson New Writer's Bursary. She teaches creative writing at Waikato University and edits the journal *Mayhem*. Her first full collection of poetry, *Conventional Weapons*, is due out in 2019.

Rachel Smith lives and writes in the Cook Islands. Her work has been published in print and online journals in Aotearoa New Zealand and overseas. She was shortlisted for the Bath Flash Fiction Award in 2018 and placed second in the 2017 National Flash Fiction Day competition.

Elizabeth Smither's latest publications are *Night Horse* (Auckland University Press, 2017), which won the Ockham Poetry Award in 2018, and a novel, *Loving Sylvie* (Allen & Unwin, 2019).

Philip Temple is an award-winning writer of both fiction and non-fiction. His latest novels are *The Mantis and MiStory* (2014); his latest non-fiction is *Life as a Novel: A biography of Maurice Shadbolt, Volume 1* (2018). He has been features editor of the *New Zealand Listener* and associate editor of *Landfall* (1972–75). In 2017 with Emma Neale he co-edited the anthology *Manifesto: 101 political poems* (Otago University Press).

Peter Trevelyan works predominantly in sculpture, with a particular emphasis on three-dimensional work informed by the methodologies and histories of drawing. In order to investigate drawing's propensity and ability to order and inform three-dimensional space, it is made to occupy and inhabit the real space it usually only references. Peter has exhibited and been collected both nationally and internationally.

Catherine Trundle is a writer, mother, anthropologist and academic based in Wellington. She writes flash fiction, poetry and experimental ethnography. Recent works have appeared or are forthcoming in *Not Very Quiet*, *Plumwood Mountain* and *Flash Frontier*.

Kirsteen Ure grew up in Port Moresby and has lived in Auckland, London and Hong Kong. She is a graduate of the University of Auckland's creative writing master's programme. In 2018 her work was awarded Headland's Frontier Prize and was commended in the 2018 *Landfall* Essay Competition.

Tam Vosper lives in Lyttelton. He is working on a PhD with the University of Canterbury English Department, writing on the subject of Allen Curnow and the poetics of place. Among sundry other distractions, he also reads and writes poems, a number of which have previously been published in the *Press*, *Catalyst*, *takahē* and *Landfall*. In 2018 he placed second in Christchurch's inaugural Metro Poems on Buses competition.

Tom Weston's most recent book, *What Is Left Behind* (Steele Roberts, 2017), was long-listed for the Ockham Book Awards 2018.

Anna Woods works in digital media and has a special interest in digital modes of reading, particularly in online reading communities. Her poetry has been published by the New Zealand Poetry Society and in *Poetry New Zealand*, and her short fiction in The Three Lamps.

Kirby Wright won the 2018 Redwood Empire Mensa Award for Creative Nonfiction.

CONTRIBUTIONS

Landfall publishes poems, stories, excerpts from works of fiction and non-fiction in progress, reviews, articles on the arts, and portfolios by artists. Written submissions must be typed, with an accurate word count on the last page. Email to landfall@otago.ac.nz with 'Landfall submission' in the subject line, or post to the address below.

Visit our website www.otago.ac.nz/press/landfall/index.html for further information.

SUBSCRIPTIONS

Landfall is published in May and November. The subscription rates for 2019 (two issues) are: New Zealand $55 (including GST); Australia $A65; rest of the world $NZ70. Sustaining subscriptions help to support New Zealand's longest running journal of arts and letters, and the writers and artists it showcases. These are in two categories: Friend: between $NZ75 and $NZ125 per year. Patron: $NZ250 and above.

Send subscriptions to Otago University Press, PO Box 56, Dunedin, New Zealand. For enquiries, email landfall@otago.ac.nz or call 64 3 479 8807.

Print ISBN: 978-1-98-853173-1
ePDF ISBN: 978-1-98-853174-8
ISSN 00–23–7930

Published by Otago University Press, Level 1, 398 Cumberland Street, Dunedin, New Zealand.

Typeset by Otago University Press. Printed in New Zealand by Caxton.

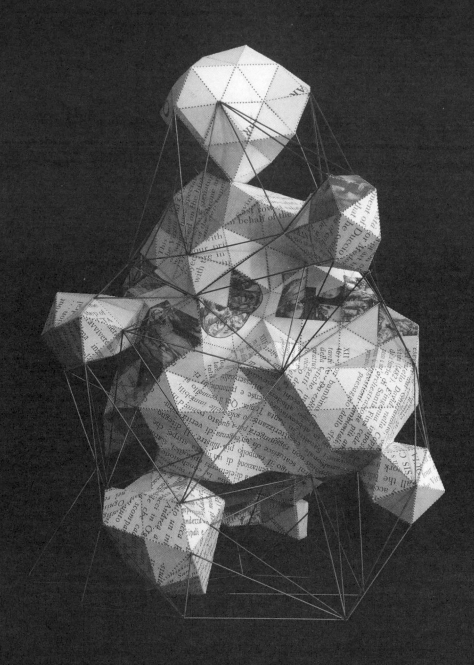

Peter Trevelyan, *orthodoxy*, 2018, graphite and found book, 230 x 200 x 170 mm.